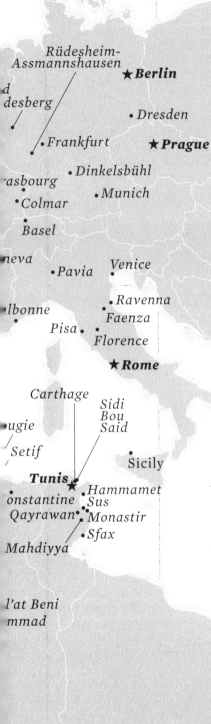

THE LURE
OF THE EAST

A CURATOR'S
FASCINATING
JOURNEY

MARILYN JENKINS-MADINA

Copyright © 2024 Marilyn Jenkins-Madina

All rights reserved.

No portion of this book may be reproduced in any fashion, print, facsimile, or electronic, or by any method yet to be developed, without the express written permission of the publisher.

Hardcover ISBN 978-1-957588-26-1
eBook ISBN 978-1-957588-27-8

PUBLISHED BY RODIN BOOKS INC
666 Old Country Road
Suite 510
Garden City, New York 11530

www.rodinbooks.com

Book and cover design by Alexia Garaventa
Photographs courtesy of the author except where otherwise noted
Endpapers: Destinations along "A Curator's Fascinating Journey"
Maps by @MSJONESNYC

Manufactured in Canada

To my beloved Maan Agha
To whom the "Lure of the East" miraculously led

CONTENTS

1
CHAPTER 1: Rising to the Occasion /
The Road Not Taken

9
CHAPTER 2: A Small-Town Childhood

19
CHAPTER 3: Education and Early Career

37
CHAPTER 4: The Adventures Begin

57
CHAPTER 5: Developing The Met's Islamic Galleries

66
CHAPTER 6: Meeting the Sheikh

78
CHAPTER 7: Creating Kuwait's Museum of Islamic Art

93
CHAPTER 8: The Reentry of Maan Agha

113
CHAPTER 9: Significant Installations and Collaborations

127
CHAPTER 10: Publication Highlights

141
CHAPTER 11: Adventures in the Middle East with Maan

154
CHAPTER 12: Treasure Hunting

171
CHAPTER 13: Life at The Wylds

186
CHAPTER 14: A Great Tree Has Fallen

192
CHAPTER 15: Kuwait Revisited

201
CHAPTER 16: Our Legacy

210
CHAPTER 17: Closing Thoughts

213
ACKNOWLEDGMENTS

215
APPENDIX: *International Travelogue*

CHAPTER 1

RISING TO THE OCCASION / THE ROAD NOT TAKEN

How does a girl growing up in Frenchtown, New Jersey, USA, become a curator of Islamic art at The Metropolitan Museum of Art and an internationally recognized scholar in the field, take more than fifty international trips, most of which were to the Middle East, at times and in locations where women were not exactly respected or welcomed in a capacity of authority, come to enjoy an enduring friendship with Kuwaiti royalty and, last but certainly not least, also become the wife and partner-in-adventure of a wonderful gentleman from Damascus who was a professor at Columbia University and also a Kurdish agha?

Throughout my life, opportunities to follow uncharted roads have presented themselves to me. I have not dismissed these uncertain paths thinking I could not navigate them. That has been the driving force in my career and my life.

THE LURE OF THE EAST

In the summer of 1962, having just graduated from Brown University that May and determined to get a job at The Metropolitan Museum of Art, I applied for a position in the Egyptian Department. But despite glowing references from my professors, I was turned down because I only had a BA at the time and I had no experience. I did not have the right credentials.

I did not give up. Finally, in August, there was an opening for a clerk typist in the Department of Near Eastern Art, which at that time encompassed both Ancient Near Eastern and Islamic art. They would consider hiring me.

I will be honest. I was frustrated that this was all I was qualified for.

My father knew how much I wanted to work at The Met, and when I complained to him that I did not want to be a clerk typist, he told me, "A foot in the door is better than no foot at all."

He was right, and his encouragement would turn out to be very sage advice. However, there was no way of knowing at the time just how large a door of opportunity this minor position was eventually going to open for me—and more than one door at that.

I accepted the job and started right away. It paid only $3,750 a year. I was to report to the department head, a wonderful Englishman named Charles Wilkinson. Mr. Wilkinson had been affiliated with The Met as early as 1920, joining the Egyptian expedition that year—one of several in which he would take part—and becoming a curator in the Department of Near Eastern Art in 1956 before being promoted to department head. Suffice it to say, by the time

I was hired, he had worked at the museum for a long time. When I took the job, I was in the section of the department devoted to Islamic art. I had taken courses in Near Eastern Studies at Brown, so the Near East was not totally unknown to me, but I still had a lot to learn.

There were only three of us in that section: Mr. Wilkinson, the curator; Ernst Grube, the assistant curator; and me. When I started, Dr. Grube was away on an extended travel grant. Then, after a month or so, Mr. Wilkinson went on vacation. With that, I became the only person in that half of the department. It seemed like it would be manageable. And then the call came to our department, a call from James Rorimer, the director of the museum at the time.

He had been a Monuments Man. For those who may be unfamiliar with this designation, the Monuments Men were a group of museum directors and curators, art history scholars, architects, and other professionals representing fourteen nations who volunteered to serve in what was called the MFAA (Monuments, Fine Arts, and Archives) program, which had evolved from the American Commission for the Protection and Salvage of Artistic and Historic Monuments in War Areas, established in 1943 by President Roosevelt, to help protect cultural treasures during and after World War II.

Mr. Rorimer was quite strict and stern. He was all business. You could hear a pin drop in the galleries under his leadership, except for the thud of his combat boots, which he stomped around in with authority. Mr. Rorimer said "no" a lot but he did not take "no" for an answer. He also did not tolerate excuses of any kind, which I was about to find out.

Now back to the call. One fall day, during that time when I was alone, Mr. Rorimer called with an urgent request—more like a direct order. The Met was in discussions at the time with Dr. Arthur M. Sackler, a psychiatrist, publisher, and pharmaceuticals marketer, who was to become a famed philanthropist and collector of art. They were discussing the renovation and reinstallation of the galleries of the Department of Far Eastern Art. Dr. Sackler, a major donor to that department, had told the museum that he very much wanted those galleries to include, in particular, the two galleries at the north end of the balcony on the second floor—two galleries that were, at that time, filled with some of the best and most important works of art in our collection from the Islamic world. Mr. Rorimer told me he wanted all of those objects removed right away and reinstalled elsewhere in the museum. This was a huge undertaking, to say the least.

For someone who had been frustrated about being hired as a mere clerk typist, I was now feeling a little over my head. I took a deep breath and explained, "Sir, there's no one here right now but me. Mr. Wilkinson is on vacation, and Dr. Grube is away also on a museum travel grant—"

He cut me off abruptly. "Then you do it."

"But I'm just the clerk typist."

His reply was expectedly stern. "Did you hear what I said?"

What else could I say? "Yes, sir. I heard."

Here I was, twenty-two years old and never having had to do anything like this before. Who would have been tasked to do something of this magnitude just out of college?

Where would I have been asked to do something like this? Only at The Met, I guess. I suppose I could have told him, "No, I'm sorry," and maybe accept getting fired. But I had been wanting to work at The Met for a long time. Now that I was here, I wanted to stay. It never crossed my mind to act in a way that might put my job at risk.

So, it was not a question of *if* I should act; it was *how* I should act.

I had only been in my position a couple of months by this time, but fortunately, I had gotten to know my colleagues in the Ancient Near Eastern half of the department. I immediately went down to their section of the department and asked them for help. They were supportive and they coached me on how to get started.

The Met has a wonderful team of individuals called riggers whose job it is to move large, heavy objects. I got their help moving pieces featured in those two galleries as well as the help of our own departmental technician, part of whose job was to move objects, when required, to various places around the building and to assist in their installation. Mind you, these were our best pieces, as these were the only two galleries in which we were able to exhibit our Islamic objects at the time. Obviously, it was a frightening process because I was moving unique and very important works of art.

I do not really remember exactly how long it all took; just that it had to be done very quickly. First, I had to determine where in the museum it would be possible to reinstall these Islamic objects. Then I had to find cases in which to display them that could be accommodated in that new area. It was decided that they could be exhibited around part of

the circumference of the second-floor balcony. Once I had been able to locate the necessary cases and have them moved to the balcony area, the relocation and installation of the objects from the two Islamic galleries could begin.

It was both terrifying and empowering that I had to strategize this essentially on my own, and quickly, and to the satisfaction of the museum's director and a former Monuments Man, but what choice did I have? This was the early 1960s. There were no cell phones or computers to send emails. Mr. Wilkinson could not be reached to advise me in any way. He literally knew nothing about what was going on while he was on vacation.

It was only when Mr. Wilkinson returned from his trip that he learned anything about what had happened. Mr. Rorimer called him into his office and told him, "Your clerk typist didn't do a bad job." Quite frankly, while the prospect of the task at hand was daunting, it never occurred to me that I could not do what was asked of me.

I believe Mr. Wilkinson must have seen this quality in me as well. When he called me in to tell me what Mr. Rorimer had said about me, he promised me that if I went back to school and got my MA in Islamic art, he would hire me back on the lowest rung of the curatorial ladder—as curatorial assistant. I was absolutely thrilled and immediately investigated schools that offered an MA in Islamic art history. Columbia was one such school; I applied and was accepted.

This was such a significant moment in my career. Throughout my life, I have experienced the benefits of a higher education and am a strong proponent of the importance of education. I firmly believe there are very few things

in this world that cannot be taken away from you, and one of these things is your education. Having this incentive to continue my education led to my eventual MA and PhD degrees, setting me well on the road to ensuring my future success.

Mr. Wilkinson retired in 1963, so it was certainly fortuitous for me to have come to the museum before his tenure was to end. In addition to education, hard work, focus, and confidence, it is clear that good luck has, in some ways, also helped me along the way. Being at The Met during the time Mr. Wilkinson was there is one important example of this belief.

He was such a lovely person, and everyone who met him felt the same way about him—that he was kind and thoughtful. He was also willing to take a chance on me. I feel that if Mr. Wilkinson had not been able to see my potential, my career would have been totally different. If Mr. Rorimer had not acknowledged my contribution the way he did, maybe things would have been different. All of this mattered so much. I have had some great support on my journey.

As I have been reflecting on events that have brought me to this moment—now retired from my curatorial career and in my eighties—I have come to realize there has been a common thread throughout my life. In addition to the encouragement and support of people who have believed in me, and perhaps more than a modicum of good luck, when it came to something I wanted to do, *it never occurred to me that I could not do it.*

I could have stayed in my hometown and built a nice family life, like so many other girls I grew up with did. But I did not. Instead, I chose another road.

There is a poem I have loved and related to my entire life titled "The Road Not Taken," by Robert Frost. It is especially these last lines that define my life's path:

Two roads diverged in a wood, and I—
I took the one less traveled by,
And that has made all the difference.

For me, it has always meant taking the road less traveled by. By writing this book, I hope to inspire others to dare to take their own road less traveled by.

You never know where the road is going to begin. You never know where it will lead. You never know where it will end—so you may as well get on it and see what you might become.

It all started when I first learned about the pyramids. From that moment of discovery in sixth grade, my eyes and ears and mind opened to the possibility of not only learning more about worlds far removed from my small-town existence, but of actually experiencing them and living them.

From the banks of the Delaware to the shores of the Arabian Gulf and beyond, this is the story of my remarkable journey.

CHAPTER 2

A SMALL-TOWN CHILDHOOD

I grew up in charming, quiet Frenchtown in Hunterdon County, New Jersey, on the banks of the Delaware River, about an hour and a half from both Philadelphia and New York City. At the time I lived there, Frenchtown consisted of about twelve blocks and had about 1,200 residents. Today, the population is just under 1,300 residents—still a small town, with an "everybody knows everybody" character.

To open a window into the quaintness of that place, here is a sampling of headlines from the several articles published about me (and which my mother saved) in the local paper fairly early in my career at The Met:

"Frenchtown Girl in Scholarly Post"

"Museum Job Entrances Country Girl"

Growing up, I did not have any extraordinary advantages. I went to public school from kindergarten through

high school. I could walk to school, which was about a block and a half from our house, so I did not even have an experience as exotic as riding a school bus. In fact, because we lived so close to the school, my parents insisted that my sister, Carole, and I come home for lunch every single day.

I was upset about this at the time because I wanted to stay with my friends, to eat in the cafeteria and play, but I think that family life and the conversations we had over lunch and dinner probably contributed a lot to who I became. I did not think about it then, but in hindsight, knowing I was part of a closely knit family was important.

I had a wonderful relationship with my parents. Throughout their lives, both were very supportive of me and my sister. I believe they instilled in me, perhaps without being aware or deliberate about it, the confidence that if I decided I wanted to do something, I could do it.

If throughout your childhood and early adulthood you are living in a home where you are loved and well-treated, you do not think about that treatment. If you are happy with what your parents are doing, you do not wonder what they could do differently. My sister and I did not grow up in an environment of fear or doubt, so neither of us came to adulthood fearing or doubting. I imagine I might not have had the confidence to move forward the way I did in my life if not for the security and strength both my mother and father provided.

Neither of my parents was involved in art in any way. Nor was anyone in my mother's immediate family or in my father's. No one in either family had been particularly interested in art before me and, later, my sister, although our parents always had nice things around the house.

A SMALL-TOWN CHILDHOOD

Carole, who is two years younger than I, studied fashion design at Pratt Institute. Early in her career, she worked in New York for the designer Vera Maxwell. When she got married and moved to New Jersey, she decided to teach high school home economics, which she did until she retired. She and her husband have been very discerning collectors of glass for many years, especially Roman and Merovingian, and are actively involved with the Corning Museum of Glass.

There was nothing adventurous about my parents, and they rarely traveled. My father (I called him Daddy) was born in Dover, New Jersey, and my mother (whom I only called Mother) was born in Aberdeen, Maryland. It is interesting that coming from this sheltered background, I would go on to travel the world.

My father was not very tall, about five-foot-four, and wiry, and he was athletic. When he was in high school, he became interested in sports, as so many young men do, and was to remain so throughout his life. In his later years, he became an avid golfer. During his school years he decided he wanted to coach sports. He attended Springfield College in Massachusetts and majored in physical education. When he graduated, he got a job teaching phys ed at Frenchtown High School, where he also coached basketball and baseball. They did not have football back then. My father's career, however, took some unusual twists and turns.

Daddy roomed in the home of a doctor and his wife while working in Frenchtown. When his athletes got injured, he would discuss these injuries with the doctor. He found himself becoming quite interested in the injuries and in their healing, and he continued to want to know more so

he could help his athletes. His interest eventually led him to decide that he wanted to go back to school and start all over again.

He applied to medical school but was told that he first had to take undergraduate courses in the sciences he hadn't needed while studying physical education. Once he satisfied those requirements, he applied to medical school again and was accepted at Duke Medical School, from which he graduated. He would continue the required preparatory work before becoming a licensed physician at Union Memorial Hospital in Baltimore, where my mother was a nurse.

My mother had three siblings. She was the baby by more than ten years, and I think she was a "surprise" to the family. She never talked much about her childhood, but I do think that because she was so much younger than her siblings, she had probably been pampered. I do not know much about her early years beyond that.

Mother went to nursing school in Baltimore and became a registered nurse, working at Union Memorial Hospital in that city at the same time my father was there. They met at the hospital, fell in love, and got married, but once they did, my mother stopped working as a nurse—although she would later sometimes step in and help my father in his practice as needed.

Although my father had left Frenchtown, he had never forgotten it. When he married my mother, they decided to move back. They rented an apartment for a while (not in the doctor's house) but soon decided to build their own home, which by happenstance was diagonally across the street from where my father had lived with the doctor and his family

years before. That is the house I grew up in and where my parents continued to live until my father's death.

Daddy was a country doctor. He was a well-loved general practitioner in the town and was also a member of the committee instrumental in the founding of the Hunterdon Medical Center, a hospital about twelve miles away, in Flemington. When he made house calls, he sometimes would take me with him if I happened to be around. I would sit in the car and wait while he visited with his patients, but I appreciated the time we had together in the car to talk and connect with each other.

My mother was instrumental in my cultural development. I think that it was she who was responsible for opening my eyes to that world, my father being so focused on his work as he was. Mother was the one who spent the most time with us. She often took Carole and me to New York City. We rode the train from Flemington into Manhattan. She took us to see the Rockettes at Radio City at Christmas time, shopping in various stores over summer vacation, and also to museums.

Of all these adventures, I loved going to the museums the most—especially The Met. In hindsight, I think my mother's taking us into the city and introducing us to a world we had not known before, living as we did in a very small and provincial town in New Jersey, certainly played a big role in my life.

When I was in sixth grade, I had a wonderful teacher named Blanche Elithorpe, who taught us ancient history. I remember that she was tall and middle-aged, and she was quite a strict teacher, but a fantastic one. She was unmarried and lived in an apartment in the telephone building in

Frenchtown. This was so long ago that our telephone number was 77. That was it. When you wanted to make a call, there were human beings that made these connections for you from the telephone building, where Miss Elithorpe lived.

Overall, I enjoyed her class. But one day, we learned about the pyramids, and that was it for me. I just fell in love with the pyramids, as some kids do at that age.

Most people get over the pyramids. I never did.

I told my parents how excited I was about the Egyptian history I was learning. Both were so supportive. They could have just ignored my new interest, but instead, they encouraged me. They started buying me books on the subject and my interest just grew. I think in part because of their encouragement and support, I never lost my passion for the subject, throughout the rest of elementary school and high school. Looking back, I realize that this passion must also have been fed by those visits Mother organized for my sister and me to The Met, which included the Egyptian galleries.

I was a good student. There were certain subjects that I liked better than others, but I was never a troublemaker, as is sometimes the case with people who go on to "break the mold" later in life. That was not me. I was focused, and always looking to go beyond and broaden my horizons. In fact, most of the few boys I dated in high school were not from my high school. They attended private schools.

As you can imagine, Egyptian history was quite a specialized interest for someone of my age in my community, so it is safe to assume that none of my friends shared my passion for it. Still, I had a number of friends throughout school, and I was very active.

A SMALL-TOWN CHILDHOOD

My father was quite passionate about classical music and instilled that love in me, a love that continues to this day. I began studying piano when I was seven and continued to do so into my high school years, only stopping because my small hand size made it difficult to play more complicated and sophisticated compositions. I was the accompanist for our high school orchestra and, later, as an undergraduate, for the Brown/Pembroke chorus for one year, ceasing this very enjoyable extracurricular activity as my academic studies consumed more and more of my time.

Throughout my childhood, there was music. My father often had classical music playing on the record player while we were having dinner. I have such a vivid memory of him, on more than one occasion, standing over a roast, waving the carving knife in time with the music as if it were a conductor's baton, before slicing the meat.

I was recently reminded of another instance of this involving my father. His medical school roommate set up his practice in Bethlehem, Pennsylvania, which was only about forty minutes from where we lived. Dr. Shields and his wife had three children. Their daughter, Alice, and I became good friends, and we remain good friends to this day. It was she who jogged my memory about the camaraderie of the two families and how much fun we always had when we were together.

My parents had built a patio on one corner of the property at the back of our brick garage, and we spent a lot of time there when the weather was nice. It had an area covered with a wooden lattice supporting climbing roses where we could sit and relax as well as eat at a redwood table with benches. There was also a built-in grill at one corner of the

patio where a low brick wall on two of its sides met. This wall was bordered by flower gardens—both the climbing roses and the flowers were carefully attended to by my parents, both of whom were interested in gardening. My father would cook meals on the grill, and the Shields family often joined us. Many times, at these BBQs, our fathers would sing barbershop quartet tunes, and my father had a wonderful voice. He really loved to sing.

I was also a majorette for most of my high school years, and we had an exceptional band. One year, we were invited to march in the Columbus Day Parade in New York City. There I was, in my short majorette outfit and my white boots, twirling two batons, not just one, in front of The Met. Who could have known that I would spend forty-two wonderful years working in that building?

I was valedictorian of my high school class, and my address was built around John Donne's poem "No Man Is an Island":

No man is an island,
Entire of itself,
Every man is a piece of the continent,
A part of the main.
If a clod be washed away by the sea,
Europe is the less.
As well as if a promontory were.
As well as if a manor of thy friend's
Or of thine own were:
Any man's death diminishes me,
Because I am involved in mankind,
And therefore never send to know for whom the bell tolls;
It tolls for thee.

A SMALL-TOWN CHILDHOOD

*On my family's patio in my high school majorette attire,
with two batons, mid-1950s*

I would love to read that address again to better understand my reasons for choosing this leitmotif for my talk but unfortunately, unlike the pyramids, it has ceased to exist. No one I am still in touch with from my past has access to it anymore.

Another thing my friend Alice helped me remember was that my parents lovingly called each other "Chick." As a child, I asked my father why they did that, and he explained it was because of a movie called *My Little Chickadee*, with Mae West and W. C. Fields. This film came out in 1940, the year I was born, and they had gotten married in 1937. Unless my father really wanted to get my mother's attention, he never called her Margaret or Peggy. Always "Chick."

Years later, without giving this custom of my parents' a single thought, Maan and I also had pet names for each other. He would call me "Habibti" and I would call him "Habibi"—the feminine and masculine for "My Love" in Arabic.

Often our parents affect us in ways we cannot imagine, even for decades after they are gone.

CHAPTER 3

EDUCATION AND EARLY CAREER

My interest in Egypt had not waned when it was time to choose a college. I was still quite passionate about the pyramids and I knew that ancient Egypt was the topic I wanted to study in university. I discovered while researching colleges that this was not a common discipline. In fact, Brown University was the only college in the entire country that offered an undergraduate major in Egyptology. (It was actually a Classics/Egyptology major because there were not enough courses offered at the time to just major in Egyptology.) Other schools offered and continue to offer graduate degree programs in the field, but to this day, Brown remains the only one with an undergraduate program in Egyptology.

I am sure that some of the other schools I applied to were much less expensive than Brown, but my parents wanted me to go where I wanted to go. I am so grateful for that.

Actually, I attended Pembroke College in Brown University, the women's college that was created in 1891 to allow women to attend classes at Brown—just as Barnard had been created for the same reason at Columbia and Radcliffe at Harvard. My degree, however, is from Brown. Pembroke and Brown were finally to become one entity in 1971, nearly a decade after I graduated.

The Department of Egyptology had only come into existence approximately a decade before I started at Brown. This was thanks to a large endowment given to the university in the name of Charles Edwin Wilbour, a gentleman who had been a prominent collector of Egyptian art in the late 1800s. Mr. Wilbour had studied at Brown in the 1850s, but was not able to graduate due to health reasons. However, he went on to make a fortune with his paper manufacturing company, and in the 1870s, he traveled extensively and discovered a love for ancient Egypt. Over the course of his life, he amassed a very large collection of Egyptian art and wrote, but never published, many scholarly articles on the subject. His collection was donated to the Brooklyn Museum by his family in 1916, many years after his death. This museum has a particularly fine collection of ancient Egyptian art, mainly because of Mr. Wilbour.

In subsequent years, Wilbour's maiden daughter, Theodora Wilbour, who had inherited much of her father's wealth, had a run-in with some of the staff at the Brooklyn Museum. She decided she was not going to give the remainder of her inheritance to that institution. Instead, she reached out to the president of Brown to offer an endowment of $750,000, to be paid upon her death. The intent of this

EDUCATION AND EARLY CAREER

endowment was to start an Egyptology department. Perhaps this was because her father had shared fond memories of his alma mater with her, but her reasoning for making this gift to Brown University is not fully known to me.

Miss Wilbour passed away in 1947, and the university received the endowment in 1948. The president of the university at the time was not that familiar with the subject of Egyptology, and was unsure about what the university's next steps should be in this regard. He did some research and found out that Egyptology was being taught at the University of Chicago. When he contacted that school and gleaned a better sense of what Egyptology was, he established the Department of Egyptology at Brown in 1948. That was my good luck, because the department was well established by the time I got there and was housed in Wilbour Hall.

I had applied to several schools, including Bryn Mawr. I was a good student, so I believed I had a good chance of being accepted at Brown, my first choice, and I was very excited when I was. However, I did not realize at the time how fortunate I was going to be in the field of study I had chosen. Generally, there are a large number of students pursuing any given major, and these students all have to vie for their professors' limited time. At Brown, there were three or four full-time professors of Egyptology—one of whom was a woman—but only one student, me, majoring in it. That meant I was able to receive really focused attention from all these professors and establish good relationships with them.

I recently reached out to Martha Milliken Stewart, my roommate during my freshman year and still a close friend, to see what she remembered about our time at Brown. She told

me something about my dormitory room during my junior and senior years that I had completely forgotten. Apparently, my single room had a molding that went all around the perimeter. On that molding, I had propped up cards with various hieroglyphs around the entire room. Even then, my love for Egyptology had extended far beyond the classroom.

Page from my Egyptian Language Comprehensive Examination, administered in May of 1962

EDUCATION AND EARLY CAREER

This recollection of hers was prompted when I mentioned an exam in hieroglyphics I had taken in my senior year, which I had found when going through the many papers I have collected over the years. It was a four-page Egyptian language comprehensive exam that tasked me to translate sentences written in hieroglyphics into English, and those in English into hieroglyphics. I couldn't imagine doing that now, but I must have done well, as I managed to graduate *cum laude*.

Martha and I shared an apartment in New York for a year after we graduated in 1962. We lived together near Columbia University while she got her MA in Library Science and during my first year working at The Metropolitan Museum of Art.

The Met, however, had not been my only possible career choice. Owing to my unusual major in Egyptology, I was approached by the CIA a few months before my college graduation to consider joining the agency to work for them in Egypt. While I have made many wonderful trips to Egypt in my lifetime (seven until now), I had only dreamed of visiting that country at that point, and was very eager to do so. After I completed the application, they asked me for names of individuals that they could interview to learn more about me. The end result was an invitation to join the agency.

I was quite tempted to accept their offer. I was intrigued, but I was also unsure. I spoke with my professors to see what they thought about my becoming a CIA agent. Admittedly, I already knew exactly what I wanted to do with my life at this time. I just wanted to know whether or not they thought it might be a good idea for me to explore this

opportunity for a short while, adding time actually living in Egypt to my credentials, before I continued pursuing a career in Egyptian art.

The unanimous advice they gave me was this: "If you do this, you will never be able to work as an archaeologist or an art historian in Egypt."

They made a good point. Being a CIA agent was a much different road to take, and their sage reservations made me realize that following this path would have worked against me down my chosen road. My professors had given me excellent advice, and I am glad I asked for their guidance.

Aside from this opportunity, there had been another possibility that would have taken me down a much different road as well. Although my father was a physician and my mother had been a nurse, I was never all that interested in medicine or science. I was all about ancient Egyptian art history. For that reason, I put off taking the science courses that I had to take to complete my BA degree until my junior year. I could not avoid taking these classes altogether; the liberal arts curriculum in which I was enrolled required courses in a number of different areas, which is a good thing. You had to take classes you otherwise would not, because doing so would make you a more well-rounded person.

To my surprise, I really enjoyed studying biology—so much so, in fact, that it nearly derailed my future. I became so serious about this topic that I remember taking the train home to speak to my father in person about possibly changing the course of my education because this class, which had a laboratory component that I particularly enjoyed, had affected me the way it had. I told him that maybe instead

EDUCATION AND EARLY CAREER

of going into ancient Egyptian art history, I would explore becoming a doctor.

Remember that this was 1960–61. It was generally expected at that time that even if a woman did choose to have a career, her husband, children, and any kind of family business would always come first. He told me, "Whatever you want to do is fine with me, but I just want you to know that I don't know one female doctor who has a normal female life."

Considering his words, I decided not to take that turn off the road I was on—although, in looking back, I realize that I did not end up having what many would have considered a "normal female life" anyway, despite not going into medicine.

When I graduated in 1962, my professors offered to help me in any way they could. Of course, I wanted to work at The Metropolitan Museum of Art, and as I have indicated, my professors gave me wonderful introductions to their colleagues in the Egyptian Department there.

Even before graduation, however, I had the support of some of my other professors. One professor in particular was Charles Alexander Robinson, a well-known classical scholar who taught Classics at Brown for more than three decades. During my junior year (1960–61), he sent a letter of introduction for me to Dietrich von Bothmer, the head of the Greek and Roman Department at The Met at the time, as I wanted to see if I could get a summer job there. Dr. von Bothmer agreed to meet with me, and I was quite apprehensive about the interview.

I remember climbing the stairs to his office, seeing him at the top, and being surprised that he was a young, attractive gentleman. While I knew him until the end of his long tenure

At the entrance to the campus of Pembroke College in Brown University, circa 1960

at The Met, at that time he reminded me quite a lot of Jack Kennedy. During my interview, I told him that I had enjoyed Professor Robinson's course and would like to have a summer job doing whatever he wanted me to do in the department.

I will never forget what he told me. "Miss Jenkins," he said, "I recently spent quite a bit of time finding a woman to fill a secretarial job here in the department. After six or eight months, she became pregnant and she left. I have no job for you."

If I had been the person I am now, I would have replied, "This has nothing to do with me, Dr. von Bothmer, because I am not married and I am not going to be having a baby. I just want to work in this department during the summer break from college." But that is not what happened at the time. I remember leaving that office so upset, thinking this was such a terrible thing to say to someone.

Before then, I had never been in the position of having a sexist opinion directed at me. However, in the early 1960s, this was not something with which people generally took issue. Still, it ruffled me. While this kind of behavior would never be tolerated today, it was common back then. It is interesting that despite what was considered acceptable at the time, I had never encountered anything like that before.

As luck would have it, several years later and very shortly after I started my job in the Near Eastern Department I saw Dr. von Bothmer near the Information Desk; better yet, he saw and recognized me. He said, "Well, Miss Jenkins, I see I didn't drive you away."

I replied to him, "No, Dr. von Bothmer, you did not."

We became good friends after that. There was a wonderful tradition of coffee hours in the staff cafeteria during

my early years at The Met where, between ten and eleven o'clock every morning, there was a table where curators from various departments could just come and join the group. I got to know Dietrich well through such informal gatherings, but that earlier interview is how our friendship began.

Before I got my job as a clerk typist in the Near Eastern Department in August of 1962, in addition to the interview in the Greek and Roman Department and as I have previously mentioned, I had also had another interview at The Met—in the Egyptian Department. But while the staff in that department were extremely nice to me, thanks to the references from my well-known professors in that field, they weren't interested in hiring me because as I have indicated, I only had a BA at the time.

I decided then, being as determined as I was, that I was not going to give up. Even as a child, I was always searching for and very often finding a way to get what I wanted, or do what I wanted to do. I have always been resourceful that way. Giving up was not something I ever did.

I can remember an example of my perseverance from the 1950s, when I was around fourteen or fifteen years old. Televisions had only just become available then, and oh, I wanted one so much, but my conservative parents had no interest in getting a TV. Around that time, our local paper, the *Delaware Valley News*, which was published once a week right in my little hometown, ran a contest. There was a double-page spread completely filled with dots—big, small, you name it. All types. The challenge was to determine the correct number of dots, and the prize was a television set.

I really wanted that TV, so I decided to count the dots and enter the contest. I divided those two large pages into very small squares, counted the dots in each square, added them up, and sent in my answer just as we were about to go on the family's annual vacation to Virginia Beach, Virginia.

Because my father was a doctor, he had all his mail forwarded during the several weeks that we would be away. One day, there was a letter addressed to me. I had won the TV!

Well, what choice did my parents have than to let us keep it? The best part was that it was not just a TV; it also had a three-speed record player in the bottom. Because my father loved music, this actually made having the TV much more desirable to him.

Our family got its first TV because I set a goal, made a plan, and achieved my goal. That has generally been my pattern. I am a Capricorn and I am methodical. Being methodical would also help me later in my life, but this is just an early glimpse of who I always was, and how I have strategized and worked to get what I want. I wanted a TV and I was not supposed to have a TV; still, I found a way.

And of course, the record player did not hurt.

So here I was, at this point, again. I had an aspiration, so I set my goal and made my plan. After my graduation from Brown, while I continued to strategize to find myself a position at The Metropolitan Museum of Art, I took a summer job in New York City in the business office of a company whose factories were located on the Delaware River, near my hometown. The name of the company was Riegel Paper Corporation, and my job was to cover for the various secretaries of the executives when the secretaries went on

vacation. Every two or three weeks or so, I would call in sick and then head to the Personnel Department at The Met to see if there were any openings in any area of my interest.

That August, I was offered and accepted the clerk typist position that presented the amazing opportunity involving the Sackler collection, which I discussed in Chapter 1, to show that I was able to think on my feet and meet a challenge that might have seemed insurmountable if I thought about it, which I chose not to do. That small, insignificant position I settled for as a way to get my foot in the door ended up getting the attention of Mr. Rorimer, earning me the respect of Mr. Wilkinson, and, ultimately, launching my career, which was to include continuing my education.

The only issue I had was how I was going to pay for graduate school. My parents had paid for Brown, but when I asked my father for help paying for Columbia, he said, flatly, "No."

It was not that he did not support my ambitions; he just wanted me to get married and live that "normal female life" he had warned me that I would never have, had I pursued a career in medicine. I, however, wanted a life that both challenged and satisfied my curiosity and ambition. My being female did not factor into the equation of how I would live my life in any way. It simply did not occur to me that it should.

I told him, "I very much want to get married at some point in time, but this is what I want to do right now."

Still, he told me, "I will not pay for you to go to graduate school."

I had to find a way to rise to the occasion and make this opportunity work for me. I was already promised a job where I wanted to be, doing what I wanted to do, if I got my

EDUCATION AND EARLY CAREER

MA in Islamic art. I started looking around for possible fellowships and scholarships. I discovered that Brown offered a graduate archeological fellowship, and you did not have to be pursuing the degree at Brown to be eligible for it—you could use it at your chosen school.

I applied for that fellowship and asked my former professors to write letters of recommendation for me, which they did. I was awarded the fellowship, but it only covered tuition. I still needed money to cover my rent, food, and other bills, so I asked Mr. Wilkinson if he had any job that I could do part-time. He hired me to work on the Coptic collection three days per week; the art—housed in our department at the time but now in the Medieval Department—of the largest Christian denomination in the Middle East, whose adherents primarily have inhabited Egypt and the Sudan since the inception of that sect.

I did not have the vaguest idea about Coptic art or the Copts themselves, so he was especially wonderful to have hired me for that part-time position I so badly needed.

Martha and I gave up our apartment near Columbia when she graduated with her MA in Library Science and got married. Then, in order to try to make ends meet, I rented an apartment with my sister, Carole, on Cornelia Street in the West Village. She was attending Pratt Institute in Brooklyn at the time, so it worked out that our commutes were more or less the same.

Fortunately for me, during the time I was doing my graduate coursework at Columbia, it was possible to complete all of the courses necessary for an MA in Islamic art in one year. This was due to the fact that, in addition to there being

an adjunct professor and an adjunct associate professor, both in the field of Islamic art, that particular year there was also a visiting professor from Turkey teaching the subject. This confluence of courses in the same field of art history all being taught during the same year rarely happens, and I was just lucky that it occurred at Columbia the very year I needed it to occur. Now I could finish my coursework and thus be able to accept Mr. Wilkinson's wonderful challenge to be hired by him as a member of the curatorial staff at The Met.

I did not complete my thesis during that year, but dear Mr. Wilkinson hired me back once I had finished my coursework. I completed my MA thesis the following year while working full-time as a curatorial assistant. My thesis was on Fatimid luster-painted ceramics. An Arab Shiite dynasty, the Fatimids began their rule in Tunisia in 909 AD, subsequently conquering Egypt in 969. With Cairo—which they founded—as their capital, the Fatimid caliphs were to rule until 1171, extending their dominion to include Greater Syria.

I knew that I wanted to continue my education and get my PhD. Not long after I received my MA, I applied and was accepted at the Institute of Fine Arts of New York University, which was just across the street from The Met at 1 East 78th Street. Its location could not have been better, as I also continued to work full time at The Met.

This graduate department of NYU was in the grand residence originally belonging to James Buchanan Duke, the American tobacco and electric power tycoon. Upon his death, his daughter, Doris, inherited the mansion. An avid art collector and philanthropist, she would in later years establish the Doris Duke Charitable Foundation, which

remains a force in supporting the arts, among other endeavors. In 1958, following one of her divorces, she gave the mansion to NYU, and the James B. Duke Residence became the building devoted to the university's graduate art history department.

At the time I was pursuing my PhD, The Met had a program to give scholarships to their employees for one course per semester if they were taking courses related to their job, and that was how I was able finance my PhD. With this wonderful program in hand and my salary, as low as it was, to cover my living expenses, I was finally able to afford renting a studio apartment of my own for $160 a month in a nice new building in the East 70s.

Also at the time I was earning my PhD, the Institute happened to have one of the most important, best-known specialists in the field of Islamic art teaching there. Dr. Richard Ettinghausen was a truly outstanding professor. He became my mentor during the time I studied under him, and was to remain so until his death in 1979. He was such a gentle and wonderful man, although he was quite a strict professor. He was also quite tall, and looked a bit like Abraham Lincoln.

Something I shall always remember about Dr. Ettinghausen (I always called him Dr. Ettinghausen) is that when my father passed away in 1972, the professor came up from his home in Princeton to pay his respects to my whole family. He was an exceptional individual in so many ways. I was so fortunate to have been able to study with him.

He was originally from Frankfurt, but left Germany during the Second World War. He moved to England, where he worked on an important survey of Persian art and then

came to America. Here he held a number of different positions in Islamic art, including teaching at the University of Michigan and as curator of Islamic art at the Freer Gallery of Art in Washington. It is while living there that he met his wife, Elizabeth, who also became a very good friend of mine over the years—especially after Dr. Ettinghausen's death in April 1979.

When Mr. Rorimer passed away suddenly in 1966, The Met needed to find a new director. They found one in Thomas Hoving, who had previously worked at the museum from 1959 to 1966 as a curator in the Department of Medieval Art and the Cloisters, rising to department head in 1965. He left the museum in 1966 to become Parks Commissioner under Mayor John Lindsay, only to return in 1967 at the age of thirty-five to assume the role of director.

While Rorimer had been a strict director who ran a very quiet museum, Hoving was much more outgoing and more of a showman. Under his leadership, The Met became an entirely different place. He expanded the museum itself as well as modified the way the objects were displayed. The attendance greatly increased. It was no longer a quiet museum. Everything was different.

One of the measures Hoving took early in his tenure that directly affected me was firing the head of the Islamic Department, Ernst Grube, who had taken over this position when Mr. Wilkinson retired. Hoving then turned to Dr. Ettinghausen, who was working just across the street at the Institute of Fine Arts, to see if he would be willing to become consultative chairman of The Met's Islamic Department. Happily, for me as well as for the museum, for

EDUCATION AND EARLY CAREER

the department, and for the field in general, Dr. Ettinghausen accepted the offer and assumed that position in 1969.

I have indicated that Dr. Ettinghausen had great intelligence, but he also had a wonderful sense of humor. I remember that one day, I was in the front office of the Islamic Department at The Met when a graduate student came to see him. She had come to ask him what the topic of her dissertation should be. He replied to her, "Miss [whatever her name was], would you like an arranged marriage?" That says a lot about the kind of person he was.

Now that I had him as a boss, in addition to being my professor and mentor, I could not have been more fortunate. What I did not know at the time, however, was that having Dr. Ettinghausen join the department would eventually lead to the incredible opportunity of being part of creating the ten-gallery installation of Islamic art at The Met, a huge and career-defining undertaking that would open so many unexpected doors for me.

One of the requirements for a PhD in Islamic art at the Institute of Fine Arts of New York University was that I had to take courses in the Arabic, Persian, or Turkish language. Since I was most interested in the earlier periods of Islamic art, when the Arabs—ruling first from Damascus and then from Baghdad—were particularly powerful, holding sway over much of the Muslim world, I decided I would choose Arabic. I started researching the best place to study this language in the city. Columbia, where I had gone for my MA, had a very strong language program in the Department of Middle East and Asian Languages and Cultures, so I decided to begin my study of Arabic there. After completing that

elementary course, I continued my study of the language by taking more advanced Arabic courses downtown at the main NYU campus, but I was blessed to discover more than a new language during that introductory course at Columbia.

The department had an interesting rule at that time mandating that at least every other year, all of its professors had to teach the beginning courses in the language of their own particular interest so as to become acquainted with the new students in the department. The year I took Arabic, a very handsome and charismatic professor, Maan Z. Madina, was teaching Elementary Arabic.

There were perhaps ten to twelve students in the class, and the professor and I bonded. We even went out for a while, but the timing was not right. First of all, he was my professor. Also, he and I had both been dating other people we were more interested in at the time. So Maan and I dated briefly in 1966, but then it just sort of tapered off.

But about a decade later, at just the right time, my path and Maan's would converge again. And that time, it would make all the difference—a dream come true.

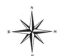

CHAPTER 4

THE ADVENTURES BEGIN

Travel was an integral part of my professional life, greatly enhancing the education I received from textbooks and in the classroom. All of the trips I took to the Near and Middle East, which accounted for thirty-seven of the international trips I have taken over the years, served to greatly increase my knowledge of my chosen field and added so much to the various publications in which I was involved. The trips I took were not just for pleasure. They were research trips. I believe that if I had not taken them, my knowledge of the field would be considerably less.

In retrospect, although I did not think about it at the time, it was not common for women to travel on their own, in either a personal or professional capacity, to the Near and Middle East, where views of women and their place in the world were more restrictive than in the West—especially during the early years of my travel to those areas. Suffice it to

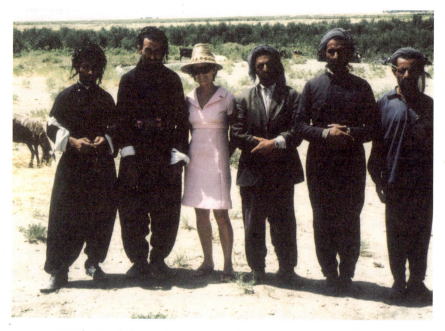

With Kurdish gentlemen in northwest Iran, between Saqqez and Maragheh, on my way to see the lotuses, 1971

say, some of the men in the countries I visited did not quite know what to make of me and my presence there.

Of the fifty-one international trips I have taken since the mid-1960s, I only covered the full cost of four. The Met paid completely for three of them. The remainder were made thanks, for the most part, to a combination of Met travel grants and academic grants, or under the auspices of foreign governments, including those made for my consulting work for the Kuwaiti royal family and the Empress of Iran.

So, beginning in 1965, travel became an essential part of my life. A trip that summer, to Italy, Spain, and England, was to be the first of my international trips. I went to Rome, Florence, Ravenna, and Venice, purely as a tourist. I had

heard so much about these wonderful cities in Italy, I just wanted to see for myself how beautiful they were. In Spain, I visited Granada, Seville, and Córdoba to see the Islamic architecture in those cities. Then in Barcelona, Toledo, and Madrid, as well as in London, I was again a tourist.

On this, my first international trip, as well as on all those to follow, I visited museums and studied the objects from the Islamic world—both those on view and those in storage. I also visited the important Islamic architectural monuments I had been learning about during my graduate studies and which, at that point, I only knew from photographs. I was also experiencing the atmosphere in the many thriving Islamic centers I visited as well.

On some of these trips I was also researching the topics for both my master's thesis and my PhD dissertation as well as specific subjects for the seven books I was to author or co-author, the thirty-four articles I was to write, and the lectures I delivered during my six-decade career. They also included academic conferences, excavations, museum openings, and Barakat Foundation board meetings. They were not just for fun, although they were immensely enjoyable.

On all of these trips, I was also taking slides to support my research—about forty-eight hundred of them. These served not only as important supplements to the illustrations of architectural monuments and objects available in books; many of them were to become illustrations in my own publications over the years as well as in my many lectures on the subject of Islamic art. In this connection, I think it is important to point out that the field of Islamic art was at that time a much newer and younger field than that of ancient

Egyptian art and thus, there was still much more groundbreaking research possible in the former than the latter. The fact that the field was in its infancy was something I was completely unaware of when I chose it.

I made my first of seven trips to Egypt in 1966, during which I visited the pyramids and the Sphinx in Giza. It was truly amazing to finally be able to experience those incredible structures. As much as I had studied and seen numerous illustrations of those pyramids in books, I was totally unprepared for the impact of their immense size as well as that of the Sphinx. It is just not possible to fully comprehend this without actually being there. Considering how much more of an impact seeing these structures in person had on me—someone who was already so passionate about the topic since first learning about it from books in sixth grade—I cannot stress enough the importance of travel. My firsthand experiences with the art and architecture I studied for so long have offered me totally different and richer perspectives on my chosen subject.

From Cairo, I hired a driver to take me to the Wadi Natrun in the Egyptian Western Desert. I wanted to see the architecture and decoration of the four Christian monasteries remaining there, which had flourished during the early and medieval Islamic periods—buildings that were contemporary to the Islamic buildings I was studying. I spent the whole day with a series of kind and knowledgeable monks, each of whom gave me a tour of his beautifully decorated monastery. All four of the monasteries are still in use today.

From there, I traveled north to Alexandria before returning to Cairo. Alexandria was founded by Alexander

the Great in 331 BC on Egypt's Mediterranean coast and flourished during the Hellenistic period. I visited that city to add to my knowledge of the country.

In Cairo, I spent quite a bit of time in the Museum of Islamic Art studying its large and important collection of objects specifically from Egypt. It only stands to reason that there would be a concentration of objects produced in a particular country in a museum in that country, which is why, being as interested as I was in the decorative arts of Islamic Egypt, its capital's Museum of Islamic Art was high on my list of places to see. Common to the museums in the Middle Eastern countries I have visited is that each one is primarily focused on its own heritage. Thus, when I went to the Museum of Islamic Art in Cairo, I saw more Egyptian pieces. When I later went to museums in Baghdad, these featured mostly Iraqi objects. I visited the museums in these various countries to better understand the Islamic objects created in each particular one.

In addition to the museum, I also visited the many important architectural monuments in Cairo that were built during the rule of numerous Muslim dynasties.

I visited the Coptic quarter of the city as well and studied the objects on view in the Coptic Museum. This Christian area of the city had buildings contemporary to some of the Islamic architecture I was studying, and I wanted to see the cross-cultural influences.

I then took the opportunity before I left Egypt to go up the Nile to Karnak, Luxor, and Thebes to visit these important Pharaonic sites. I went to these places, again, to broaden my knowledge of the culture of the country.

THE LURE OF THE EAST

Thus, I left Egypt having attempted to experience during my first visit to the country the major architectural monuments and decorative arts of its three major cultures: the Pharaonic, the Christian, and the Islamic.

In 1969, I took a fascinating trip to a number of places in the Middle East with my friend and colleague Louise Mackie—one that lasted about three weeks. The motivating factor was to take a "study trip," to fill out the book learning I had done on a particular subject, country, or object by seeing it in person. Most of my trips were study trips.

Traveling with Louise was not only an opportunity to visit with her; it was a safer way to experience some of the more isolated major monuments in our field and places less traveled. Going totally alone to some of these places was not really advisable for many reasons, so it was better—not to mention nicer—to be going with someone else, and Louise was just a wonderful travel companion.

Louise was to become a textile curator at the Textile Museum (now part of the combined George Washington University Museum and Textile Museum) in Washington, DC, then department head of costumes and textiles at the Royal Ontario Museum in Toronto, Canada, and finally, curator of textiles and Islamic art at the Cleveland Museum of Art. However, when we took this trip, we were both just beginning. We still stay in close touch and we get together whenever she is here in New York. She and I recently talked about this wonderful trip, and we both feel it really broadened our horizons.

While this was my second trip to the Middle East, my father seemed to have had particular reservations about

my safety regarding this one. He said, "Lyn, I'm going to drive you to Kennedy Airport myself because I don't think I'll ever see you again." He knew that he could not stop me from doing what I was doing, and that I was determined to go on the trip. But he wanted to spend as much time with me as possible before I left.

Because I was working on my dissertation by this time—the subject of which was the glazed pottery tradition of North Africa and Spain from the middle of the ninth until the middle of the twelfth century—my trip started in Tunisia, where I could study that country's early Islamic ceramic production. I spent time in the major museum in Tunis, the Bardo National Museum, and I also visited the city of Qayrawan, which is a World Heritage Site. Its exquisite Great Mosque dates from the ninth century.

At the time, Louise was attending the American University in Cairo working toward her master's degree. The plan was that I would meet her in Cairo, and we would travel together as far as Iran.

In traveling to Cairo from Tunisia, my plane was to fly via the Tripoli Airport in Libya. It just so happened that the day I was making this trip was September 1, 1969, which was the very day Muammar Gaddafi came to power. This was an unsettled time in the Middle East. Gaddafi, who had been rising in the ranks of the Libyan Army in the mid 1960s, had been planning a coup to overthrow King Idris I. On the day of my flight to Cairo, he seized control of the government and became head of the Revolutionary Command Council, which essentially alienated Libya from other Middle Eastern countries and much of the world for decades.

Neither I nor the other passengers had any idea what was going on at the time, or what the impact was going to be, but our plane was grounded at the Tripoli airport for some time. As you can imagine, this was somewhat frightening for me and my fellow travelers. I was happy when our plane was finally allowed to take off. Only later did we find out everything that had happened. I can only imagine what my parents (and especially my father) were thinking, watching the news back in the States.

Other than that scare, I had a wonderful trip. I stayed in Cairo for a few days, and Louise hosted a party for me so I could meet several of her newly made Egyptian friends as well as some of her fellow students from the American University in Cairo, including Manuel Keene, another American studying Islamic art, who would later become a colleague of mine as well as play an unplanned, serendipitous role in Maan's and my coming together again. She and I then flew to Jordan where, among other cultural sites, we visited the museums in Amman, which is the capital, and the eighth-century desert palaces outside of Amman. Built under the Umayyad Dynasty—the first Islamic dynasty, which ruled from Damascus from 661 to 750—the palaces were built as retreats. Three of them are among the most memorable: Mshatta, Khirbat al-Mafjar, and Qusayr Amra, which is a World Heritage Site, with frescoes that are particularly striking.

It was quite an extraordinary experience to be driven across the barren desert to these wonderful very early buildings and to see some of their decoration, consisting of mosaics, frescoes, and sculpture, still very much intact.

THE ADVENTURES BEGIN

We also hired a driver to take us to Petra in the southern part of the country. We pretty much had that ancient city to ourselves. We entered the city by walking through a mountain pass along the Wadi Musa, which is the dry riverbed leading into Petra. The city opened to us in all its splendor when we reached the end of the pass. This famous archaeological site was the capital of the Nabataean Kingdom. Petra flourished in the first century AD, and has been a UNESCO World Heritage Site since 1985. Its most spectacular rock-cut building is also listed as one of the New Seven Wonders of the World.

We were having a wonderful time wandering around the city, but it was incredibly hot. As we were making our way up a long series of stairs leading to one of its buildings, we heard someone shouting. We looked around to find a young man with a cooler. He ran ahead of us, opened the container, and took out some bottles of nice and cool Coca-Cola for us to buy. Of course, he had a captive audience. Because we were so hot, I think we would have been willing to pay $20 for a bottle should that have been his now long-forgotten asking price.

After returning to Amman, we made our way to Syria. We visited Damascus and its myriad wonderful architectural monuments from the Islamic period. The Great Mosque, which dates from the early eighth century, with its stunning mosaic decoration surely was near the top of this list. We also went to the National Museum of Damascus to view their exquisite objects on display, the focus of which were works of Syrian production. Because Damascus was such an important center in the Islamic world, we were able to visit major monuments in that wonderful city from numerous centuries and dynasties.

Continuing north from Damascus, we went on to Homs to visit the nearby Krak des Chevaliers, a beautiful crusader castle still standing from the thirteenth century. The castle, which now is a UNESCO World Heritage Site, is located on a hill over 2,000 feet high. The vista from there was quite extraordinary.

We then moved on to Hama, famous not only for its own wonderful architecture but also for its water system consisting of huge wooden waterwheels (noria) on the Orontes River—a system for irrigation dating back at least to the late twelfth century, but no longer providing the water supply to the city.

From there we continued to Aleppo where, among the many beautiful and important architectural monuments this city contains, the early thirteenth-century citadel is a particular standout, which, unfortunately, received significant damage between 2012 and 2016 during the lengthy Battle of Aleppo. Then we went to Iraq. We loved being in Baghdad, although it was beastly hot. Louise had written in her notes that it was 107 degrees one of the days that we were there. We were delighted to learn that the museums in the city were air-conditioned, as we were planning to spend quite a bit of time in those.

The museums we visited in Baghdad were particularly beautiful. We learned that the Iraqi government had sent its curators to various eastern European museums for training as to how to lay out exhibitions, and consequently, the exhibits were quite well done. Some of the museums were housed in older, historic buildings that had been repurposed, and thus their architecture was also impressive. One of the most beautiful was a museum that was housed in a building called the al-Mustansiriyyah, which dates back to 1233.

THE ADVENTURES BEGIN

While we were in Iraq, we also traveled north from Baghdad to Samarra. One of the buildings you learn about when studying Islamic architecture is the now mostly destroyed ninth-century mosque in that once-thriving city with its stunning and still pretty much intact 52-meter-high (172-foot) spiraling minaret. The function of a minaret is to allow the call to prayer, which takes place five times a day, to be heard throughout the city; the person who calls the hours of daily prayer is the muezzin. The Great Mosque in Samarra, which is a World Heritage Site, was completed in 861. The design of its minaret has inspired and continues to inspire Western architects to this day in their own designs for buildings serving varied purposes.

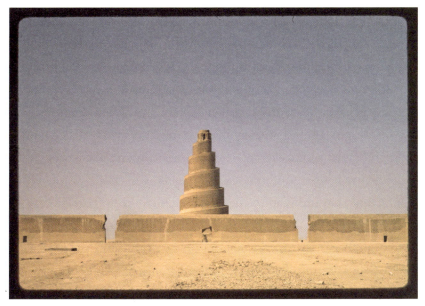

Minaret of the Great Mosque in Samarra, Iraq, completed in 861. This may have been one of Frank Lloyd Wright's inspirations for his design of the Guggenheim Museum in New York City.

Marilyn Jenkins-Madina Archive, courtesy of Aga Khan Documentation Center, MIT Libraries (AKDC@MIT)

After our stay in Iraq, we traveled to Iran. Arriving in Tehran, we stayed at the British Institute of Persian Studies. Many young scholars and students did the same because it was much cheaper than hotels. We met other individuals in our field while we were guests there.

One such person was Jennifer Scarce, who held a position at the National Museum of Scotland in Edinburgh. One day, Louise and I, along with Jennifer, got the idea to visit a particular building we had all learned about while studying Islamic art. This beautiful fourteenth-century mausoleum is in Sultaniyeh, which is west of Tehran and halfway between Tehran and the Iraqi border.

Sultaniyeh had briefly been the capital of the Ilkhanid Dynasty, which ruled Iran and neighboring countries from 1256 to 1335. The building we went to see was the tomb belonging to the Ilkhanid ruler Uljaytu, who ruled from 1304 to 1316. It was a splendid tomb, and is all that remains of a much larger tomb complex.

Despite the fact that none of us spoke a word of Persian, we decided to take a local bus. Something Louise recently reminded me about was that when it was time for prayer, the buses would stop so the passengers could pray. That was always very moving to me, knowing that, even when traveling, people would get out and pray next to the bus, or that we would stop in a village at the appointed prayer time so the travelers could pray.

We did not have the money to hire a car but were determined to see the mausoleum, so we tracked down a bus schedule. We knew from the direction we were headed which side of the bus the mausoleum would be on, though

we had no idea how long it would take to get there. The other passengers were mostly rural people, some riding with chickens on their laps, and seeming unsure about these three young Western women riding the bus with them.

We all knew we would recognize the burial complex when we saw it from the window of the bus. We knew the mausoleum would be quite tall, with beautiful turquoise tiles on its domed roof. As soon as we spotted it, we all jumped up and signaled to the driver that we wanted to get off the bus. Even though we could not speak a word of Persian, everyone on the bus seemed to understand what we wanted to do, but from the looks on their faces, they could not understand why. I imagine they thought we were out of our minds.

The driver stopped the bus and we got off. We started walking toward the building, although we knew neither quite how far it was to the complex nor that we were walking across a farmer's field. He ran up to us and spoke, but we could not understand what he was saying. We tried to communicate to him that we were going to the building in the distance. He seemed to understand that, and also just how far away the tall building in the distance really was; he loaned us his donkey. I still have pictures of myself on the donkey, with the beautiful Sultaniyeh mausoleum in the background. Jennifer, Louise, and I took turns riding his donkey.

This nice farmer trailed us, but from a distance. I imagine his staying back was meant to be polite, but following us was to ensure his donkey would be returned to him. According to the notes Louise took and shared with me, we arrived at our destination in about forty-five minutes. The farmer caught

My trip via donkey to the stunning fourteenth-century mausoleum in Sultaniyeh, Iran, 1969

up to us and took his donkey back, and we spent a few hours studying the building and admiring in person this wonderful highlight of fourteenth-century Persian architecture. The tomb was definitely worth the trip we made to see it, and was named a World Heritage Site in 2005.

We had planned that when we had finished, we would walk back to the road to catch the bus again so we could make it to our next destination. As we were nearing the end

of our visit in Sultaniyeh, a diplomatic couple arrived to visit the complex. Fortunately, they spoke English. We told them about the donkey and they asked, "How are you going to get where you're going next?"

We explained that we would be walking the forty-five or so minutes back to the road and would then hail the bus to Qazvin, where we were going next, and we knew the bus schedule. They told us, "Fortunately, we're also going to Qazvin. We will take you with us."

During June and July of 1971, I revisited Tunisia, Egypt, and Iran. The trip would end in Athens followed by Berlin. During this trip, I joined the ongoing excavation of Fustat, which had been the capital of Islamic Egypt before Cairo was founded in 969 AD. Fustat had flourished during the period that was of particular interest to me. The excavation, headed by George Scanlon, who was a professor at Princeton, was carried out by the American Research Center in Egypt, which awarded me a grant to work on the excavation.

I lived on a houseboat on the Nile with the other students and scholars on the team that season. It was docked close to the center of Cairo. This meant when we were not working, we could explore the city quite easily and enjoy living in Cairo.

We had to start working quite early in the morning because of the extreme heat; by eleven, it was just too hot and we had to stop. I was not digging; I was there to help the excavators determine the techniques that had been used to make the objects being unearthed, and when. My job was to catalog those objects including ceramics, glass, and metalwork, and to help determine their dates.

THE LURE OF THE EAST

After leaving Cairo, I traveled to Iran, where I made an interesting excursion to the northwestern part of the country and the Caspian Sea. At the time, I was working on thirteenth- and early fourteenth-century Persian pottery. This pottery incorporates many motifs, but one that was particularly popular was the lotus. I knew that the lotus was introduced to Iran when the Mongols conquered the country in the thirteenth century. I had heard that the lotuses brought from the Far East were still growing abundantly just offshore on the southern coast of the Caspian Sea. I wanted to see and photograph them.

I hired a driver to take me to that area of the Caspian, where I hired someone with a motorboat to take me out to the lotuses. We did not need to travel too far from the shore, but they were far enough offshore that we needed a boat to be able to see them up close. As we got closer to the lotuses, we were stopped by the Caspian police. Apparently, the motor was disturbing the sturgeon that produced the golden caviar for the Shah and his family and entourage. The engine had to be turned off, and the boat had to be rowed from there. The lotuses did not disappoint in any way. Their extremely large size and beautiful and vibrant rose color as well as their immense leaves were simply stunning to see bobbing on the surface of the Caspian.

Louise Mackie also recently reminded me that Dr. Ettinghausen had asked the museum to send me, as well as another colleague, to the Staatlichen Museen zu Berlin in the Dahlem district of Berlin at the end of this trip so we could visit that museum's new installation of Islamic art, since we were working on the ten new galleries of Islamic art at The Met at the time.

THE ADVENTURES BEGIN

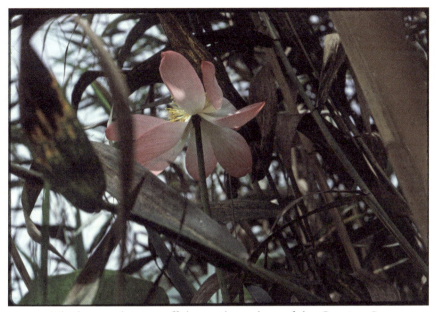

The lotuses thriving off the southern shore of the Caspian Sea
Marilyn Jenkins-Madina Archive, courtesy of Aga Khan Documentation Center,
MIT Libraries (AKDC@MIT)

I am realizing now the importance of Dr. Ettinghausen's amazing foresight. He was always so many steps ahead of us. He wanted for me and my colleague to see for ourselves the innovative approach used by this museum to present its Islamic objects in order for us to better decide how to organize the galleries at The Met.

As part of my dissertation research, I visited Algeria in both the summer of 1972 and the fall of 1973. During the 1973 trip, a professor at New York University, Norman Stillman, and his wife, Yedida, who was originally from Morocco, joined me. I needed to visit Qal'at Beni Hammad in central Algeria to study the remains of this city, which was founded in 1007–08 AD. On the way from Algiers to

Qal'at Beni Hammad I was also interested in seeing the remains of the tenth-century city, Sedrata. I had been told the sand that had covered it over time had been removed. Norman did the driving.

One day when we had stopped for lunch on our trip south, the waiter delivered a note to our table from another group in the restaurant. The note said that they were Americans working on a pipeline and had heard us speaking English. As they had not heard English spoken in such a long time, they asked if they could join our table. Naturally, we said yes.

These two or three men were so happy to meet people with whom they could speak English that they offered to spend a day with us and take us wherever we wanted to go. That was advantageous for us, as they had vehicles better suited to the desert terrain we knew we would encounter than was the car Norman had rented.

On our trip into the Algerian desert to see Sedrata, our Jeep got stuck in the sand! This was in the days long before cell phones. We had no idea what we were going to do. We all got out of the car and finally, after many unsuccessful attempts extending over quite a long period of time, managed to push it out. We were totally petrified.

When we finally got out to the road again, we saw the sign for Sedrata, with the information as to the number of kilometers into the desert it was located. We took a picture of Norman standing in front of the sign, wildly gesturing, "No!" Sedrata had been "nowhere to be seen," as its remains had been totally covered again with sand. It remains buried under the sand, but it is classified as a natural heritage site.

THE ADVENTURES BEGIN

The French were in control of Algeria for 130 years and my trips occurred shortly after the country became independent. It was a very exciting time to be there. However, as is the case with so many of the countries I have traveled to during the dozens of international trips I have taken, Algeria is not as safe to visit as it once was, and other countries on my itineraries are literally impossible to visit now.

While all this was going on in my life, many of my contemporaries were getting married and starting families. I knew how much my father wanted me to get married. Remember, he told me he would not pay for graduate school because he wanted me to live a "normal female life," but he never nagged me about it. My sister got married at a fairly young age, so I think she may have taken the heat off me in that regard.

I guess my father and mother understood that I was enjoying what I was doing, but my poor father—my taking all these trips around the globe as a single woman without any marriage prospects or even the slightest desire to get married was so far from his conservative upbringing and mindset. However, he knew I was happy. He never said, "You can't live in New York," or "You can't travel," or told me I could not do anything I wanted to do. By this time, he knew that even if he told me I could not do something, if I wanted it badly enough I would find a way to do it, like winning that TV when I was in high school, or going on to graduate school, and probably a long list of other things I cannot remember from when I was growing up.

Many of my friends at that time seemed to be governed in a different way, doing what was normal and expected of

them. I was going off in a totally different direction—taking the road "less traveled by." I did not think about this at all, really, at the time. The road I was on just seemed normal to me. I simply continued on my path, and if it took me in one direction or another that I thought I should follow, I would just go in that direction on that road.

My father passed away in 1972. He was only sixty-eight at the time, but he had an aggressive form of cancer that took him quickly. Very sadly, he was no longer around when Maan and I got reacquainted. Although I am not sure he would have approved of the way we conducted our relationship, as Maan and I did not get married until after more than a decade together, I am sure he would have adored Maan.

CHAPTER 5
DEVELOPING THE MET'S ISLAMIC GALLERIES

While I was doing all this traveling during the 1960s and 1970s as well as studying for both my MA and PhD degrees—securing the latter in 1978—I was also working hard to build a successful career at The Metropolitan Museum of Art.

I was part of the curatorial team responsible for setting up ten new galleries—the largest installation of Islamic art the museum had ever undertaken up to that point in its 105-year history. I was in charge of the first five galleries, which included objects dating from between 650 and 1250 as well as those from the later Arab dynasties up to 1517. It was a big responsibility.

While traveling has been a very important leitmotif of my life, immeasurably enriching it both personally and professionally, I believe there have been three major highlights in my career. Those highlights include the permanent

installation of the new galleries for Islamic art at The Met, which opened in 1975; directing the project to create Dar al-Athar al-Islamiyya (Museum of Islamic Art) in Kuwait, which was the first in the Gulf and opened in 1983; and co-authoring *Islamic Art and Architecture 650–1250*, which was published in 2001 and is still the go-to book in graduate schools for the study of Islamic art and architecture produced during those six hundred years.

This chapter will focus on the first of these highlights—the exciting period between 1971, when it was decided that The Met should have a large permanent installation dedicated to Islamic art, and the opening of that installation in 1975, along with the process by which this huge undertaking moved to its completion.

I mentioned earlier that Dr. Ettinghausen's involvement in this endeavor would create a significant opportunity for me, and it did. He is the person who put me in charge of the first five galleries of this installation.

I asked Dr. Ettinghausen if perhaps we could ask Manuel Keene, whom I had met in Cairo at the party Louise had given for me, to be part of this project once he finished his degree. In speaking with him at that party, I had learned that he was especially knowledgeable about early Islamic art, and his specialty was geometrical design, a very important decorative element in that art. I thought he would be able to make valuable contributions to the installation, and Ettinghausen agreed to hire Manuel.

A great deal of work goes into the preparation for such a large installation, and many different departments of the museum were involved. For example, and to name just a few,

the actual design and layout of the galleries was very carefully coordinated with the Exhibition Design Department. The wall graphics as well as all of the many labels had to be written and produced in coordination with the Editorial Department. Stands and mounts had to be constructed in order for many of the objects, both large and small, to be displayed, many of which had to be conserved before being exhibited, those tasks being undertaken by the Conservation Department.

When we were working on these galleries, I had to be an expert in all things Islamic produced during the years and in the areas for which I was responsible. Not having been in the field for very long, I remember that a number of times I had to go back to Dr. Ettinghausen's office and ask him questions. He had edited important periodicals devoted to the field of Islamic art, so he could practically cite page numbers for me where I would be able to get a full answer to a question. It was just wonderful. This was another big bonus: my being there at the right time, and his being there at the right time.

Even with Ettinghausen guiding the process, the installation was a big responsibility. Fortunately, however, I had already been at The Met more than a decade. I was a long way from the young woman who had been tasked by Mr. Rorimer in my first months on the job to move and reinstall all of the objects in two galleries, rooms that contained some of the best and most important works of art in our collection from the Islamic world. Still, I was faced with an enormous challenge that was certain to have a major impact on my career going forward. (However, I never could have

predicted the myriad opportunities to which bringing these galleries into existence would lead.)

At that point in my tenure, I had quite a good understanding of the art history of the objects in the Department of Islamic Art. In addition to earning my MA and working toward my PhD, I had also already worked on some smaller exhibitions at The Met as part of my curatorial duties, and had published several articles. Indeed, I was ready to rise to the challenge and excited to put my knowledge and expertise to work for such a groundbreaking endeavor.

Gallery within the 1975 installation exhibiting objects excavated by The Met in Nishapur in eastern Iran—the hometown of the famous Persian poet Omar Khayyam

Image © The Metropolitan Museum of Art

Although The Met, which was founded in 1870, has the largest comprehensive collection of Islamic Art in the world, the first department in the museum devoted to the art of the Islamic world was not inaugurated until 1932. Nearly 60 percent of the Islamic collection of approximately 11,000 objects came to The Met during that sixty-year period before there was such a department. Until that time, all the objects from the Islamic world were under the aegis of the Department of European Sculpture and Decorative Arts.

As I wrote in an article decades later about this period, "Collecting the 'Orient' at The Met: Early Tastemakers in America," and about which I shall speak more in Chapter 10:

> During the last quarter of the nineteenth and first quarter of the twentieth centuries, the great interest in travel to the Middle East that had earlier spawned a vast travel literature in Europe was to be found in America as well. Some of the travelers during this period were artists whose images of or motifs from the "Orient" were influential in fueling a nascent curiosity about the Islamic world and its art. Also part of the travel fever and equally important in creating an interest in the Middle East in America at this time were the four international expositions held in the United States during the period under discussion: two in Philadelphia—one in 1876 and the other in 1926—a third in Chicago in 1893, and another in St. Louis in 1904. Each

of these fairs, like their European counterparts, to a greater or lesser extent offered its visitors the opportunity to take an imaginary journey through a number of countries, including those of the Islamic world.

Due to this burgeoning interest, an important market arose at that time for objects from that part of the world. A small group of dealers, most of whom were of Middle Eastern origin, sold such objects amongst their large holdings to a number of collectors with a growing interest in this "exotic" area of the world, many of which were, in turn, donated to The Met during the time before there was a department specifically devoted to art of the Islamic world.

Once there was such a department in the museum, the curators became responsible for making additions to the collection. Over the decades since the inauguration of the department, these additions have been made through purchases and gifts as well as an excavation sponsored by The Met.

One of the dealers who contributed to the surge in interest in the field of Islamic art during the first half of the twentieth century in the United States was Hagop Kevorkian. He had moved to the States from Turkey in 1920 and established a business selling objects from the Middle East. One of the acquisitions he made during his travels was a spectacular reception room from Damascus dated 1707 AD/1119 AH (AH stands for Anno Hijra, the year when the Prophet Muhammad migrated from Mecca to Medina, an event that occurred in 622 AD and marks year one of the Islamic lunar calendar).

Gallery within the 1975 installation exhibiting objects in the collection created for use in mosques, the centerpiece of which is a spectacular mid-fourteenth-century faience mosaic mihrab from Isfahan, Iran

Image © The Metropolitan Museum of Art

Mr. Kevorkian brought the room to New York in the 1940s and then tucked it away in a series of crates in a storeroom under the West Side Highway. About thirty years later, in 1970, The Kevorkian Foundation gave this room to The Met, just in time to be included in the museum's new installation of Islamic art. We decided to make it one of the ten galleries—a period room of sorts.

When the room was given to us, however, nobody knew precisely how it should be installed, as Mr. Kevorkian had passed away and no one else had seen the room in situ. When I was put in charge of its installation, I asked to be sent to

Damascus to see and study similar reception rooms in order to better understand how it should come together.

When I returned, we hired a firm that specialized in installing period rooms. While in Syria, I had taken many photographs to help in this process and these, together with the expertise of the firm in knowing how to follow every lead inherent in the room itself, including the original nail holes, led to the installation of this beautiful early eighteenth-century room. We were hoping to secure a gift from the foundation to cover the costs associated with the installation, which we did and for which we were most grateful, as it was to become a favorite of our visitors.

The Kevorkian Foundation has remained a generous contributor to The Met over the years, funding various efforts in both the Islamic Department and the Ancient Near East Department, including a special exhibition gallery within the Islamic galleries—a single gallery where we can do small exhibitions drawn from the collection.

The way the new galleries were organized was quite innovative at the time. Rather than having each one devoted to a single medium, as had almost universally been the case for installations of Islamic art both here and abroad up to that point, we decided to organize the installation chronologically instead and thus mix the media, with each gallery devoted to the art of a specific period of Islamic history. This gave us the opportunity to tell a more complete and succinct story of each period; for example, the types of objects, textiles, jewelry, manuscripts, calligraphic scripts, and so forth that were in vogue during any given period. The labels in each case and the wall graphics in each gallery were composed to help

the visitor better understand the historical background of the period being presented as well as the various objects in use and the architectural elements employed during each period.

The installation was finally completed and had its grand opening in the fall of 1975.

Curators of Islamic collections from museums around the world attended the opening to see the fruits of our labor with the extensive, exceptional, and world-renowned collection with which we were privileged to work.

The way we approached the installation would influence how Islamic art was exhibited going forward, something that made everyone associated with this huge endeavor very proud. The installation also finally showed for all to see the immense depth and breadth of the collection of Islamic art in The Metropolitan Museum of Art, a well-deserved accolade that we were also so proud to have helped unveil.

As important as being a part of creating these galleries had been, however, I had no idea at that time that some of the most exciting adventures I would have during my long career were still on the horizon. In fact, Louise Mackie recently told me that I had confided in her not long after the installation had been completed how let down I felt—being unable to imagine what could equal it for me going forward and be more or as meaningful as this extraordinary project had been for me. Little did I know at the time that this achievement, stunning as it was, was only the beginning.

CHAPTER 6
MEETING THE SHEIKH

During the period the Islamic galleries were being developed, I had occasion to visit my primary care physician, Dr. Eric Andreae, whose office was close to The Met. I told him a bit about my work, and he was quite interested in how everything was coming together.

Dr. Andreae was a member of the Westside Clinical Society of Physicians. When he was made head of that group, he shared with me that it had a meeting once a month, the subject of each being medicine except for one meeting a year when the subject could be anything but medicine. He asked if, for the one meeting not about medicine, I would be willing to take the group through the new Islamic galleries before they opened. I told him I would be happy to, but that I first had to check with Dr. Ettinghausen, who, in turn, would have to get permission from the director.

We got the green light and set a date that, at the time, seemed far enough into the future. But as is often the case

with museums, and certainly for The Met, as the date got closer, we were not at the point we should have been in completing the galleries.

I explained, "We'll have to put the tour off, because except for a few things there is very little in the galleries yet to show them."

He replied, "Are you kidding? A large number of people have signed up for this tour." He had also reserved for the evening the entire restaurant in the Stanhope Hotel, which was across Fifth Avenue from The Met at the time. "We're all going to be eating there afterwards," he told me. "You have to do something."

Of course, I could not *not* do something. I could not disappoint Dr. Andreae. I knew I was going to go through with it, but with nothing really to show, I had to figure out what to do.

I have explained that my parents helped instill in me a sense of confidence, which made me more determined to rise to this occasion. I am reminded of a time very early in my career when my father gave me some really good advice, which I believe—even if it was not at the front of my mind at the time—was actually quite helpful in this particular situation.

In that earlier time, I had been scheduled to give a lecture at a scholarly conference on Islamic art. Even though it would be my first such lecture, I told my father I was not nervous at all about delivering it because the topic was something I had been working on for some time, and I felt I probably knew the subject better than anybody who might be in the audience. However, it was the questions they

might ask during the question and answer session afterward that were concerning to me.

Here is where his wonderful advice helped me, as it had so many times before. He told me, "Never be afraid to admit you don't know the answer to a question. Just say that you don't know but that you will be happy to look into it and get back to the questioner." He then added, "You'll find that many people are very pleased that they're able to sort of stump the expert."

That was, and still is, such good advice. I have never forgotten his words, and they have come in handy over the years, especially on the occasions when I have given tours in the museum. People have asked me questions from time to time that I was unable to answer, and they were quite pleased when I was not able to do so.

Now I was faced with a situation in which I had the answers, but I had very little to show the audience to generate the questions. I realized I would have to make the whole thing up. So, I rose to the occasion and improvised.

The installation of the beautiful eighteenth-century reception room from Damascus had been completed and was, at that time, at the entrance to the galleries, so there was that to show. Then, back in the far corner of those ten galleries, we had, at that point, already installed a beautiful sixteenth-century Spanish ceiling that had come from the Hearst Foundation.

We had also raised the floor of that gallery so as to create a pit into which we could unroll a stunning 27-foot, sixteenth-century carpet from Cairo. We planned to exhibit it in the pit so people could observe it in its customary

MEETING THE SHEIKH

position without being able to step on it. However, the rug had not been installed yet. Essentially all I had to show the large group at that point was the impressive ceiling, the rug pit (sans rug), and the Damascus Room, which had been donated by the Kevorkian Foundation.

Much as I had done in the case of the Sackler situation when I first started my job at The Met, I had to wing it. I greeted the large group of physicians and began my tour of essentially nothing.

We spent a good deal of time in the Damascus Room, which they loved. Then, as we walked through the empty galleries, I explained what was planned for each of them, giving a very brief description of the various dynasties whose objects were to be exhibited in each. With some creativity and a fairly extensive knowledge of the collection, I was hoping to be able to paint an intriguing picture for the attendees.

When we got to the corner room with the Spanish ceiling and the pit, I instructed as many people as possible to sit around the opening in the floor with their feet dangling into the pit. Then I showed them slides of what was going to be displayed in all the galleries.

This all turned out to be an experience to remember. Anyone could walk through a museum and have the objects that are already in place explained to them; this was a special experience because it gave the group a "behind the scenes" look at what would be going into a large museum installation. I joined the dinner afterward and answered many questions from members of the group. Dr. Andreae confirmed that everyone who had attended simply loved the tour, and

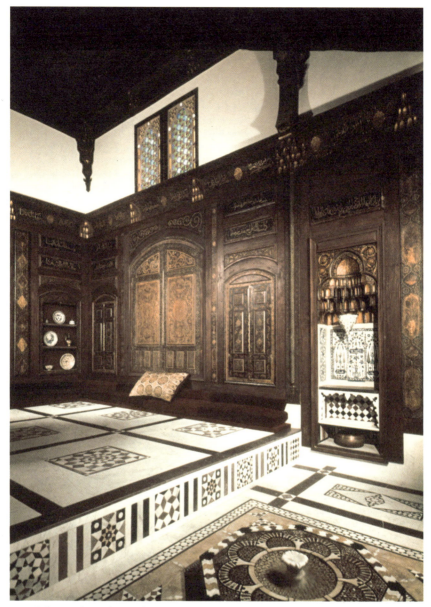

The early eighteenth-century reception room from Damascus in the 1975 installation—the sole gallery in the suite of ten completed in time for my tour for Dr. Andreae's group of doctors

Image © The Metropolitan Museum of Art

MEETING THE SHEIKH

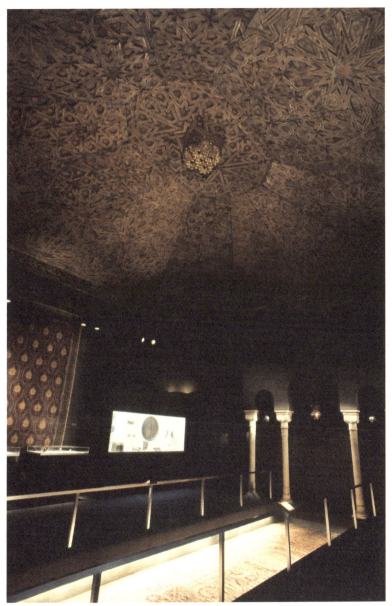

Gallery within the 1975 installation with the beautiful sixteenth-century Spanish ceiling below which a number of the tour group sat—around the then-empty carpet pit—and watched my slide show

Image © The Metropolitan Museum of Art

even more so, in fact, than if the objects I was showing them were already hanging on the walls or installed in cases.

A few years after the galleries opened, a doctor who had been part of the group called Dr. Andreae to say that a patient of his at Columbia-Presbyterian Hospital was a member of the Kuwaiti royal family and that her son, who was an avid collector of Islamic art, was coming to see her. The other doctor asked Dr. Andreae if he could ask me to take her son through the galleries.

That collector was Sheikh Nasser Sabah al-Ahmad al-Sabah, with whom I would go on to have a most wonderful, more than four-decade friendship, together with his wife Sheikha Hussah Sabah al-Salim al-Sabah. He had first become acquainted with and interested in Islamic art when he was a high school student in Jerusalem.

He and I met in the spring of 1978 around the time of his thirtieth birthday, and our enthusiasm for the art of the Islamic world served to cement our friendship from that very first encounter. After I showed him the galleries, he asked me if I would connect him with some dealers in the city and take him to meet them. I had to get permission from the museum to do that because private collectors were competitors, but it was granted.

From the moment I met him, I found Nasser to be quite down-to-earth and a lovely person to be with. He had a great sense of humor. He was interested in so many things, and he was always eager to learn new things.

As an example of the latter, I will share an anecdote about him that occurred after I had known him for a while. He contacted me about a metal object he had bought in

Afghanistan. He wanted me to give him my opinion of the piece. I told him that metalwork was not really an area of my expertise in the field of Islamic art, but that there was a colleague of mine at Oxford University that I could connect him to who was a specialist in that area. I was sure that he would not mind speaking with Nasser about some of the metalwork questions he had, and Nasser said he would very much like to meet him.

Katie Marsh, who was the managing director of Sheikh Nasser's London office and who later became involved with his collection, as well as becoming a good friend of mine over the years, called the professor at Oxford. He came down to London during one of Nasser's visits there, and he too found Nasser very eager to learn. He told me it almost felt like Nasser was "sitting at his feet," so closely was he listening to everything the professor had to say. That was the way Nasser made him feel—that he was conveying important information and that his words had value. That was the way Nasser made everyone feel.

Not thinking he knew everything there was to know about what he was collecting was one of the reasons that Nasser's collection was as good as it was. He was never afraid to say, "I don't know," and then ask questions and actually listen to the answers. Many collectors I have known over the years have thought they had all the answers themselves and did not bother to ask specialists about what they had, and their collections showed it. Nasser was quite different, right from the very start. He was easy to be with because he always gave the impression that he was interested and excited to learn more about what he was seeing.

THE LURE OF THE EAST

A few months after we first met in New York, Sheikh Nasser called to invite me to come to Kuwait to see his collection and meet his wife, Sheikha Hussah. As luck would have it, I had already planned to be in Egypt that fall, so I told him I could add Kuwait to my itinerary at the end of that trip.

Nasser sent his private plane to Egypt to take me to Kuwait. I met Hussah and I also got to know Nasser better during that trip.

Nasser and Hussah are both members of the Kuwaiti royal family. Her father, Sheikh Sabah al-Salim al-Sabah, ruled Kuwait from 1965 to 1977. Nasser's father, Sheikh Sabah al-Ahmad al-Jaber al-Sabah, ruled from 2006 to 2020, and passed away only a few months before Nasser, who died in December 2020. But money and power never defined them. They were and are such down-to-earth, thoughtful, and caring individuals. Kind and loving. Purely elegant and never ostentatious, from how they dress to how they live. Nasser would always be in traditional Kuwaiti dress, except when he was in Europe or America, and Hussah always dresses in a beautiful but understated Western style.

They have a lovely property right on the Arabian Gulf (also know as the Persian Gulf) in Kuwait City. They hired the famous Egyptian architect Hassan Fathy, well known for designing in a style that fits the terrain, to design their house that so beautifully conforms to the local landscape, which was just what they wanted. That is just the kind of people they are.

During my first trip to Kuwait in 1978, Nasser and I hardly knew each other. As I mentioned earlier, he invited me to see his collection and meet his wife, but he also, as it turned out, wanted to introduce me to his country and its history.

MEETING THE SHEIKH

Early in my visit, Nasser assembled some musicians to perform for me. When we arrived at the building where this was to take place, there was a group of maybe eight or ten men, sitting on the floor of a stage. As they played their instruments, Nasser talked to me about these men. They did not speak English at all, so we were free to converse without them understanding what we were saying.

I was surprised to learn that each one of these men was quite well-to-do, and that all of them had started out as pearl fishers. Nasser explained that the economy in Kuwait before striking oil was maintained by men such as these, diving for pearls. Each of the musicians had originally made their living in that way and helped to keep Kuwait afloat financially. The royal family was so grateful for the men's efforts when the country needed them that they wanted to repay them. But the men were proud; they would not take any money. For that reason, the royal family got the idea to ask them if they could buy their homes. They knew the men would not refuse, because of their good manners as well as tradition, and all of them were paid a large amount of money for their small, simple houses.

I have never ever forgotten this story because it was so moving. Nasser was so proud of these men and his country, he wanted to share this story with me. And these musicians did not have the vaguest idea that I was being told their story. It was wonderful. I also have always wondered whether this experience was responsible for the very special regard in which I hold Bizet's opera *The Pearl Fishers*. It is one of my favorites.

Another day during my visit, Nasser and I went by motorboat—his own boat, with Nasser himself at the wheel—to

an island off the coast of Kuwait called Failaka. There was a small museum there, and it was the only museum in Kuwait at the time. He wanted to show me what his country had then in the way of museums so he could better describe for me what they wanted in the future.

It was during that first visit to Kuwait that Nasser introduced me to his already large and quite comprehensive collection of Islamic art which, at that time, he kept in his home. The opportunity this trip afforded to actually see his entire collection really gave me a clear picture as to the kind of collector Nasser was.

As I would later write of Nasser, in my introduction to the publication that I edited for the opening of the Kuwait National Museum:

> The Sheikh is an inveterate collector and an intuitive connoisseur with a highly refined taste, trained eye and photographic memory. He has a boundless enthusiasm which sustains him during the sometimes long pursuit of an object, a coolness which stands him in very good stead during its capture and a genuine love for beautiful things in general and Islamic art in particular which is reflected in the manner in which he cares for and lavishes attention on an object once it is his.

I made my second trip to Kuwait, my shortest-ever trip to the Middle East, from January 28 to February 1, 1979. My travel arrangements had been organized through Nasser's

MEETING THE SHEIKH

office in Kuwait. This time, however, there had been a mix-up, and he was out of the country when I arrived. No one from his office was there to greet me and take me to the hotel as there had been for the first trip.

I went to the information desk at Kuwait Airways to get some help, telling them that I was expecting Sheikh Nasser or someone from his office to be meeting me.

The person at the desk asked me, "Which Sheikh Nasser?"

That day I learned a lesson I have never forgotten. In the Arab world, it is not only the first (or the last) name that matters; it is all the names that come in between as well. At that time, I did not know Nasser's full name. "I don't know which Sheikh Nasser," I replied.

"There are so many Sheikh Nassers," he told me.

The staff at the airline were quite helpful. They called a very high-ranking Sheikh Nasser, who was one of the ministers in the government and a close relative of the Sheikh Nasser I had come to see. In fact, he might even have been Minister of State at the time. He came to the airport to speak with me and after making a call, he told me, "I'm very sorry. I just spoke with Sheikha Hussah, and she told me that Nasser is not in the country and will not be returning very soon. We have arranged for you to stay in a hotel for a couple of days before returning to New York."

From that day forward, I knew that Nasser's full name was Sheikh Nasser Sabah al-Ahmad al-Sabah, and that Hussah's full name was Sheikha Hussah Sabah al-Salim al-Sabah, each of their names incorporating the names of their fathers.

CHAPTER 7
CREATING KUWAIT'S MUSEUM OF ISLAMIC ART

Some time after my initial visits to Kuwait, Nasser asked me if I would be willing to serve as the Islamic art specialist as part of a UNESCO group that the Kuwaiti government had commissioned to provide some ideas for a museum complex that had been built a number of years before on the Arabian Gulf. He had shown me these buildings during my first visit, but we had not discussed this opportunity then.

I got permission from the director of The Met at the time, Philippe de Montebello, to be part of this UNESCO group, and spent two weeks in Kuwait in April of 1981 with specialists in many of the various aspects of museum organization who were also part of the group. There were four different buildings in the complex, and each was intended to have a different function.

The complex had been designed by the well-known French architect Michel Écochard. He had been given the

challenging task of designing the buildings before they even knew what was to go into each of them.

We had many meetings and discussed various possibilities during that two-week period. We then prepared a report, which was sent to the UNESCO headquarters in Paris. There it was translated into Arabic and sent to the Kuwaiti officials who had commissioned this group. I then returned home, not knowing what would become of all the ideas we had presented in our report.

Some time later, Nasser called to tell me the report had gone "into the circular file"; in other words, into the wastebasket. I have always assumed that the government officials who had commissioned it felt the plans presented by the UNESCO group were too complex.

He was not deterred. Instead, he said to me, "Lyn, let's us show them how to do one building"—meaning, transform one building of the four-building complex into a museum of Islamic art comprised of his large and very comprehensive collection, which was, from the beginning of the project and remains until now, on loan to the Kuwait National Museum. (Each of his objects bears an accession number with the prefix LNS, which stands for "Loan Nasser al-Sabah.")

After much thought and securing the necessary permission from The Met, I agreed to take on his challenge. It was a wonderful opportunity for me to undertake a project that would not only create what would turn out to be the very first of several new museums of Islamic art in the Gulf, but allow me to do so with one of the largest and most outstanding and comprehensive private collections of Islamic art at the time.

View of the gallery in Kuwait's Dar al-Athar al-Islamiyyah (Museum of Islamic Art) incorporating the splendid pair of doors from Fez
The al-Sabah Collection, Kuwait

I was really on my own as to how this museum would come to be, without any restrictions at all. Nasser put it all in my hands, and I did it. Because, as has been my pattern, I could not *not* do it.

I learned pretty quickly that installing a number of galleries in a museum for a permanent installation or temporary exhibition is one thing; setting up an entire museum, and a large museum at that, halfway around the world, and all while I already had a full-time job at The Met—this was a

whole other thing entirely. But Nasser remained confident. "You can do it any way you want," he assured me. "I'm not going to oversee anything."

He believed in me. I believed in myself. Of course this was going to work out.

Then he told me, "The only thing I insist on, however, is that I want the museum to open on February 25, 1983, which is our national day. So that's all. Everything else is up to you."

It is important to timestamp the story here: We were already in the fall of 1981 by this time. So, in less than eighteen months, I had to organize, oversee, and be ready to open an entire museum—in a country on the other side of the world, while I already had a full-time job in the States.

I am not sure what I was thinking except, again, there was no way I could *not* accomplish this.

Nasser had a very large collection, but very little was cataloged. That meant my first order of business was to determine exactly what he had so I could organize the layout of the three-story building and plan the installation of the objects on the various floors. In order to accomplish this, I would spend about two weeks at a time in Kuwait, then return to New York for two or three months, then head back again. I also had to hire staff to help me in Kuwait, as well as a designer.

At the time, I was working on a Mamluk exhibition at The Met with a designer from the Exhibition Design Department named Charles Ryder. We worked well together, and I introduced him to Nasser and Hussah when they came to see that exhibition. He made a favorable impression on them, as had the exhibition, and they hired him to transform

the interior of the building so as to be able to accommodate Nasser's collection and make certain it was exhibited in the best possible way.

It became evident early on that I would not be able to spend a lot of time in Kuwait because of my quite demanding full-time job at The Met. For this reason, I needed someone that I could count on and who could be there full-time in Kuwait. Once again, I reached out to Manuel Keene, whom I had also brought in to join the team working on the Islamic galleries at The Met. Manuel was totally fluent in Arabic, and I learned he was not working at the time. After the galleries at The Met opened, Manuel had left the museum and returned to Arkansas. I got Nasser to hire Manuel to be the curator at the museum, and I worked with Manuel from New York while he was based in Kuwait.

During the time I was cataloging Nasser's collection, it was in his house, so that is where I worked. I stayed in the local Hilton and a driver took me back and forth each morning and evening.

While Nasser was usually either at his office or traveling when I was doing the cataloging, Hussah, on the other hand, was around most of the time. She said to me, "I very often entertain my sisters, aunts, and nieces for lunch. Don't let us distract you."

I said, "Don't worry."

So, Hussah went about her normal routine including entertaining and I kept focused on my cataloging project. Then, one day when no one else was around, she approached me. "Is there something I can do to help?" she asked.

At the time, she was collecting Alexander Calder. Since she did not know anything about Islamic art—Nasser being the collector in that area—I did not think there was anything she could do. "No, Hussah, but thank you," I told her. "There's really nothing for you to do to help me."

I imagine she was not used to having people tell her "no," but she seemed to accept "no" for an answer.

Because I was at their house every day while I was cataloging the collection, she and I would often have lunch together when she did not have other guests. Sometimes I would also stay for dinner. We got to know each other quite well during this time.

After a while, she said again, "I really want to work with you."

I then thought of something she could help with, but I worried she might think it was beneath her. "Will you do anything I ask you to do?"

"Yes."

I said, "I need someone to number and measure each object in the collection."

"I'll do it!" she said.

She is a Capricorn, like me, and she was very diligent. She carried out her work beautifully, and working together as we did each day brought us even closer together.

One night, over dinner, she said, "You know, maybe I'd like to work in this museum. Can you tell me some of the jobs to be found in museums?" At that time, she did not have any idea what went on behind the scenes in museums.

I explained to her that there are curators, "like myself," I told her.

She responded, "Curators have to know a great deal about the field, and I don't know about the field." That was true, but she was undaunted. "I can't be a curator, but describe for me some of the other jobs."

"Well, there's the director. . ."

"What does the director do?"

I told her.

"Perhaps I could be the director. Many of my close relatives head various governmental departments, so I could easily speak directly to the minister of the particular department from which we needed help."

Who was I to tell her that she could not be the director?

As luck would have it, the phone rang near the end of that meal—or near the end of one of our other dinners shortly after that particular discussion; that detail from decades ago is not quite clear in my memory. It was Nasser calling while on one of his travels. She said to him in English, "We have a new director of the museum."

He obviously must have asked, "Who is it?"

She replied, "I think I'd better put Lyn on the phone."

When I got on the phone, he asked me who the new director was. I said, "It's your wife."

"You tricked me," he told me.

To which I replied, "Nasser, I didn't trick you. I think she would be a very good director. Why don't you give her a chance?"

Finally, he said, "Okay. She can be the director."

Hussah was breaking new ground for women in that part of the world, something she would continue to do and is still doing today.

When we reached the final stage of installing the objects in the museum, which in all took about two months, my driver would pick me up early every morning from the hotel and deliver me back in the very late afternoon. Hussah would come to work at the museum each morning between ten-thirty and eleven o'clock. She would then leave around two or three in the afternoon.

After observing her routine for a while, I said, "Hussah, if you're the director, you have to come to work when your staff does, and stay until your staff leaves. You're responsible for the work that's going on right now."

She replied, "But I can't do that. I can't leave the house until Nasser leaves the house. And I have to be there when he gets back."

So, I said, "Hussah, at the very least, could you ask Nasser when he's coming home?"

"Oh, no, I can't do that."

"Well, then I'm really very sorry. I don't think this is going to work."

"Will you give me a little while to work this out?" she asked.

What could I say? Of course, I had to say yes.

One day shortly thereafter, she told me, "I have it all worked out with Nasser. We have terminated your driver and I'm going to take over his role. I can pick you up every morning—so you will get to work on time, and I will get to work on time—and I will have to take you home when you're finished work."

She had managed to find a way to make it possible for her to be at the museum when she was expected to be there

while, at the same time, finding a way for Nasser to be able to explain to his friends and acquaintances why his wife was stepping out of the usual frame and breaking with protocol. Hussah was thrilled that she could be there all the time. She was and is an amazing individual. She is a perfect example of "breaking the glass ceiling," and the beautiful example she set in this regard would serve as a model for other sheikhas in the Gulf to do the same.

Hussah and I also worked very closely during the installation itself, and she got her friends and aunts and nieces to come and volunteer, as well. Everyone had a wonderful time. Proof of how much her female friends and relatives enjoyed helping prepare the museum for its opening was brought home to me during the opening itself. One of the gentlemen I greeted in the receiving line was the husband of one of these women. While shaking my hand he said to me, "You are the only person I know who could make my wife a slave."

During the final stages of the installation, several of the men from Nasser's office whom he had sent to help me complained to him that I was bossing them around. He told me he said to them, "You can yell and scream about her all you want when you're at home. But when you're in the museum, she's the boss."

This is the type of person Nasser was, showing as it does how someone of his stature, during that era and in that part of the world, not only defended me to his employees (regarding what was surely a complaint based on my gender) but also told me that he had done so.

After the museum was open, Hussah, as director of the museum, from time to time had to travel outside Kuwait to

meet with other directors. Early in her tenure, she always traveled with a companion. These days, however, she makes these trips on her own.

Throughout the now forty years since the museum opened, Hussah has thrived in this position. She often lectures now and is also on several boards, including that of The Met. Before the COVID-19 pandemic, she would come to New York a couple of times a year for the trustees' meetings. We would spend a great deal of time together while she was here.

I have so many special and wonderful stories about both Hussah and Nasser. For example, I asked Nasser what kind of events had been planned for the museum's opening festivities, which I knew were to last for an entire week, because I had to make sure I had the right clothes before leaving New York for the two months it would take to put the necessary final touches on the installation before the opening week.

He told me, "Leave the clothes for the opening events to me. Just give me your size, and I will choose the clothes for those particular festivities."

Nasser went to Paris with some of his entourage and bought clothes for Hussah and me to wear for those very special occasions. And for the most important evening, he brought me three dresses from which to choose my preference. Princess Diana was very much in the news at the time, and he had picked one that was very Princess Diana-ish. That was not me. Another one felt a bit femme fatale, which also was not me. The last was a Balenciaga, which I chose and which I loved wearing.

Nasser also told me, "I want your mother and your sister to come."

With Sheikh Nasser and Maan during the opening festivities for Kuwait's Dar al-Athar al-Islamiyyah in February of 1983, with my sister, Carole, in the background

The al-Sabah Collection, Kuwait

Maan was also invited. He and Nasser had first met, through mutual friends at the UN, during Nasser's trip to New York in 1978 to visit his mother in the hospital—the same trip during which I first met Nasser. They were to become very good friends over the years, as was the case with Maan and Hussah as well.

He also wanted to invite Dr. Andreae, my physician, whose request for a tour of the Islamic galleries at The Met about a decade before had culminated in this event.

Nasser asked me to help compile the guest list for the opening. He instructed, "I want you to write down everyone you think should be on the list." He was looking to me

CREATING KUWAIT'S MUSEUM OF ISLAMIC ART

for the scholars in the field of Islamic art, because at that time he didn't know many of them. He provided the names of dignitaries from around the world as well as the dealers with whom he had worked.

I have an interesting story to share regarding the invitation list for the opening, having to do with King Hussein of Jordan asking me personally to be included.

I had gotten to know Doris Halaby, who lived in New York. I do not recall how I met Doris, but she and I had lunch together maybe two or three times a year. Her husband, Najeeb Halaby, was the president of Pan American Airlines. Their daughter, Lisa Halaby, who had gone to Princeton, became the queen of Jordan.

When Doris found out I was planning to be in Amman, Jordan, during one of my trips, she told me she thought her daughter would very much like to meet me, as Doris knew that I was involved in the Kuwait project, and she believed her daughter might like to hear more about it.

I met Queen Noor at the palace and we had a lovely visit. After I had been there for some time, all of a sudden, she said, "My husband's coming to see you."

King Hussein came in a few minutes later, and said to me, "I understand you're doing a museum for Kuwait. Could you put me on the invitation list? I would really like to come."

Of course, I told him I would be very happy to see that that happened, and the three of us ended up having a nice conversation. Something must have come up that made it impossible for him to attend the opening, but I will never forget how much he wanted to be included on the invitation list.

Approximately four hundred people were invited to the one-week event, most of whom came. All Nasser asked was for each guest to get themselves to either New York, London, Paris, or Geneva, and he would fly them from there to Kuwait, then cover all their expenses.

It was a magnificent royal celebration. Everyone was amazed by the quality and size of Nasser's collection and the stunning installation, which included being able to admire from the top floor of the museum a magnificent, very large Persian carpet displayed in a shallow pit on the lowest floor. It was a truly glorious occasion, one that so many of the invited guests will never forget.

And to think, this wonderful connection was made through my doctor, after taking his group on a tour through ten galleries at The Met that were practically empty. Looking back on it now, it seems extraordinary. I have often thought that if it had been a regular, straightforward tour, things would, most probably, have turned out much differently.

Very sadly, when Saddam Hussein sent his army into Kuwait in 1990, the soldiers took everything out of the museum and set fire to the building. They then trucked the objects to Baghdad. Everything we had painstakingly installed, thousands of precious, irreplaceable objects, were buried in the desert outside of Baghdad together with the objects from the Iraqi museums, to protect them from the war that was raging.

When the war ended in 1991, the United Nations invited a group from the Kuwait museum to Baghdad where they were, thankfully, able to recover all of the works of art stolen from the museum. The only group of objects that

CREATING KUWAIT'S MUSEUM OF ISLAMIC ART

Sheikh Nasser and Sheikha Hussah during the opening week of the museum with the beautiful now-destroyed fourteenth-century Moroccan doors as background

The al-Sabah Collection, Kuwait

were part of the original installation that did not survive this catastrophe were the many jeweled objects that Nasser and Hussah had removed from the museum to their home for safe-keeping when they first learned of the impending invasion, objects that were later stolen from the house and whose present whereabouts are unknown. Another single object, a magnificent pair of Moroccan doors from Fez dating from the fourteenth century and measuring almost 15 feet in height were too large for the invading army to move and were burned when the building was torched. Only the iron fixtures could be retrieved from the doors' ashes.

Over the decades since the objects have been recovered, a number of them have been loaned to other museums throughout the world, either as part of special exhibitions or as long-term loans. As this is being written, more than thirty years after the invasion, the rehabilitation of the building itself is currently, and finally, under way. Once that is completed, the reinstallation of Nasser's extraordinary collection can begin.

I would very much like to return to Kuwait for the official reopening of the renovated museum, but it could take several more years from the time of this writing, and probably longer. Only time will tell.

CHAPTER 8

THE REENTRY OF MAAN AGHA

Beginning my relationship with Nasser and Hussah was just one of the momentous events that happened in 1978. I also received my PhD and, after all I had gained, I let go of something that had plagued me since I was seventeen: a three-pack-a-day Marlboro cigarette habit. And that's not all.

That same year, in fact, just a few weeks before I met Nasser that April, I became reacquainted with my former Elementary Arabic professor, Maan Madina, after a hiatus of twelve years, and we officially began our romance.

When Maan and I met again, it was truly serendipity. An important auction of Islamic art was being held at one of Sotheby's auction venues in New York, P.B. 84. I recently reached out to an old friend, Richard (Dick) Keresey, whom I first met in 1967 when he was a summer intern at The Met and who is currently the Worldwide Director of Egyptian, Classical and Western Asiatic Antiquities for

Sotheby's. Dick used to handle Islamic objects for them as well. (Sotheby's New York venue no longer deals in Islamic objects.) I asked him if he would be able to track down the exact date of the auction, and he did: it was Wednesday, March 22, 1978. I thanked him profusely for being able to ascertain that date.

I had wanted to attend that auction, but I had something to take care of earlier that day so I was not going to be able to be there when it started. I asked my colleague, Manuel Keene, with whom I had worked on the ten galleries at The Met (and whom I would eventually bring in to help on the Kuwait Museum project) if he would save a seat for me. When I arrived at the auction, Manuel had saved the seat between himself and Professor Madina. I mean, you cannot make this up. Plus, Manuel did not know Maan, so it was not even a question of his sitting next to somebody he knew.

It had been more than a decade since I had last seen Maan, but he was the same handsome gentleman I remembered. We greeted each other warmly and I sat down next to him. Because the auction had already started, we did not talk.

As the auction proceeded, he bid on a few things. One of the lots consisted of a pair of beautiful ceramic vases from Raqqa, Syria, from the late twelfth or early thirteenth century. Even though he had had his hand up the entire time, the auctioneer did not see him bidding, and he did not get the objects.

Maan knew the auctioneer, and Maan being Maan, he walked right up to her and told her that he had been bidding. She told him she had not seen his hand up.

She asked me, "Did he have his hand up?"

"He had his hand up the entire time," I assured her.

With that, they put the objects back up on the block. This time, she watched for his hand, and he got the pair of vases he wanted. I still have them both in our apartment.

Dick recently emailed a photograph of the cover of the catalog to me, as well as of the page where the lot was listed. In those days, it seems, the auctioneer would write the sale price of each lot next to its description. One price had been written in, then crossed off because the lot had been reauctioned. The second price is written on the page as well.

Maan was delighted that he had gotten the objects and invited me to come and see them in his apartment once he had gotten them home. The rest is history. From 1978 until his death in January of 2013 we were together.

Interestingly enough, I recently remembered that shortly after I remet Maan at the auction, a mutual friend of ours, Jack Josephson, had invited both of us to a party one evening at his apartment. I remember it was on Good Friday that year, so I looked up when Good Friday fell in 1978. It turns out that it was exactly two days after I saw Maan at the auction. So, it seems that if Manuel had not saved a seat for me next to Maan, we were likely bound to meet up again just a couple of days later at Jack's party. It seems that destiny was finally ready to bring us together.

Our relationship was just seamless. We never could understand, however, why it took so long for our paths to cross again, because he was very actively collecting Islamic art during that twelve-year hiatus, and he would go to all the auctions of Islamic art in the city, as would I. He also very often visited the Islamic galleries at The Met.

As I mentioned earlier, Maan first met Nasser that spring as well. They were introduced through mutual contacts at the UN during Nasser's trip to New York to visit his hospitalized mother, which is when I too first met Nasser. Apparently, upon their first meeting, as soon as Nasser heard Maan's last name, he asked him if he was related to Rasha Madina. Maan replied, "She's my half-sister." Nasser then told Maan that he was a big fan of Rasha's, who was a noted TV personality in Egypt at the time. Maan said that Nasser then went on to praise her television program very highly. So, Nasser and Maan bonded over this connection right away.

When I remembered this conversation, I wrote to Maan's half-brother, Dureid (Rasha's full brother) and his wife, Sawsan, who live in Sydney, Australia, asking, "I'm wondering if you could tell me about her program, and how best to describe her job. Any help you can provide in this regard will be very much appreciated."

They wrote back right away, letting me know that Rasha was a beautiful woman who wrote poetry and studied economics and political science at Cairo University. Later, she worked as a television presenter and became quite famous working on many cultural and current affairs programs.

One of Rasha's shows was an hour-long program during which she interviewed the giants of the Egyptian stage and cinema. The Egyptian movie industry was the principal movie industry in the Arab world at that time, and wherever you were from in the Arab world, you would watch Egyptian cinema when you were not watching American movies. In fact, Maan used to say that he could understand

THE REENTRY OF MAAN AGHA

the Arabic dialect spoken in Egypt extremely well from watching Egyptian movies.

Maan and I came from different worlds, and we each enjoyed learning all we could about the other's. Maan's story is intertwined with my own, so I feel it is important to share parts of his. After all, he was certainly the most compelling "lure of the East" for me.

When Maan was very young, maybe three or four years old, he went to visit his maternal uncles in Acre, Palestine. One day, he happened to sit on a scorpion and got stung. He started to cry quite a lot, until one of his uncles sternly said to him, "Kurds don't cry."

He never forgot that. Maan was taught to keep a stiff upper lip from a very early age, and never complained very much over the years—even when he was terminally ill. This was an important aspect of who he was.

Maan was a Kurdish agha. "Agha" was an honorary title of respect under the Ottomans, which can be translated as "lord" or "master" and was not unlike that of "nobleman" in the West. The first known member of Maan's family to be addressed with this title resided in Diyarbakr, Turkey, during the early nineteenth century, and the title in the family goes back at least four generations. In each successive generation, the eldest son came to be addressed as "Agha." Maan's full name was Ma'n Agha ibn 'Ali Agha ibn Zilfo Agha ibn Madina Khanum Zaza.

The correct transliteration from Arabic for his first name is "Ma'n." The second letter of his name in Arabic does not exist in the English alphabet and thus, the reason for the use of the apostrophe. Shortly after coming to

America, however, he decided to simplify this transliteration and began spelling his name "Maan," which I have used throughout this book.

Several members of Maan's family, especially on his mother's side, played important roles in Middle Eastern history. One ancestor, Kara Mustafa, was the Ottoman grand vizier between 1676 and 1683. The Grand Vizier was a very high-ranking official during the Ottoman Empire, serving as the sultan's representative in the government. Kara Mustafa fought John III Sobieski, King of Poland, at the failed siege of Vienna in 1683. Another was Ahmad Pasha al-Jazzar, the Ottoman governor of Acre, who fought against Napoleon during the siege of Acre in 1799 and successfully defended the city. He is buried in Acre, and there is a mosque in that city in his name called al-Jazzar Mosque.

Maan's father, 'Ali Agha, had four wives, and Maan was one of eighteen children. They all lived together in a beautiful eighteenth-century house in the Kurdish quarter of Damascus, which is now a school. It had a lovely interior courtyard with a fountain in the center and a large reception room. All the various sections or wings of the house radiated out from the courtyard; each of the four wives and her children lived in one of the four major sections or corners.

Maan told me that there is no word for privacy in Arabic. With his very large family and all the comings and goings of eighteen siblings and their four mothers, you can imagine that privacy was pretty hard to come by. Maan had had an older brother who died as a very young man, at which time Maan became the eldest son, and thus the one who inherited his father's title of Agha.

Maan's father, 'Ali Agha, with four of his ten sons. Maan is at the upper left.

The way it seems to have worked in a family with four wives was that when a new and younger wife joined the family, the responsibilities in the marriage of the older wives changed accordingly, including her sexual role. Maan's mother, who was his father's first and oldest wife, was to become the mistress of the house, and according to one of the daughters of the youngest wife, someone she thought of as her grandmother.

The Qur'an permits a man to have four wives simultaneously, but specifies that each wife must be provided for equally in all ways. Maan explained to me that, for this reason, in the cities, only wealthy men could afford to have four wives. This tradition in Maan's immediate family essentially ended with his father, as none of 'Ali Agha's ten sons were polygamists.

Seven of Maan's brothers and sisters lived in Cairo. Every time we went to Cairo, we visited with them. We enjoyed going to Cairo because there was so much beautiful Islamic architecture to see and study and museums to visit. Whenever we took a trip to the Middle East, we would often just stop in Cairo to visit with Maan's siblings there. All had the same mother, but theirs was not Maan's mother. One of the seven, his sister Malak, was married to Abdul Hamid al-Siraj, the vice president of the United Arab Republic under Gamal Abdul Nasser. He had uncovered a plan for an assassination attempt on Nasser's life and tipped him off. Among the rewards to thank him for this, all of Malak's brothers and sisters in Damascus were invited by President Nasser to come and live in wonderful homes in Cairo.

THE REENTRY OF MAAN AGHA

Maan and his half-sister, Hoda, in Egypt in July of 1965—one year before I was to become his student at Columbia University

One of these brothers, Dureid, and his wife Sawsan, whom I have already mentioned in connection with one of Sheikh Nasser's favorite TV programs, also shared a story with me about another of Dureid's sisters and Maan's half-sisters, Hoda. During a holiday while some of her girlfriends who attended the American University of Beirut were back home in Cairo, one of them said to her, "We have a lecturer who is as handsome as a movie star. Many of us are smitten. His name is Maan Madina."

"That's my brother," she told them.

Maan's youngest half-brother, Hussein, told me a story about an event that happened before Maan assumed that academic position, a story that Hussein's mother, the fourth and youngest of the wives, had shared with him.

One day in 1953, there was a knock at the door of the family's home, and Maan's mother, Najiyya Khanum al-Kurdi, told Hussein's mother to answer it. When she did, Maan, who had been away in graduate school in the United States for a number of years, was outside. When his mother heard his voice, she was so happy that she started running around the courtyard and fountain with great excitement. Maan had to run around the courtyard himself in order to be able to greet her warmly after such a long separation.

She had not been expecting him, to say the least. There were no cell phones or computers at the time and no way other than by letter to let anyone know he was coming, so he essentially just suddenly appeared after being away for six years. He explained that he had come back because he was working on his dissertation, and he had been offered a position as a lecturer at the American University of Beirut,

THE REENTRY OF MAAN AGHA

his undergraduate school—the job during which he was described as "a movie star" by the friends of his half-sister in Cairo.

I never met Maan's father, who, like my own father, passed away before Maan and I became a couple. I do know, however, that Maan's father had fought with Lawrence of Arabia. And like Maan, he was also very handsome, tall with striking blue eyes, and like his son had a tendency to stop admirers in their tracks. Maan's half-brother, Dureid, also told me that Maan's mother had told him that when 'Ali Agha visited Acre, the girls would stand behind the shutters at the windows, taking peeks at the tall, handsome man as he walked down the street.

At some point while he was studying for his PhD at the University of Chicago, Maan's father stopped sending him money for school. The reason for this was that during an interview he had with a newspaper in Chicago, Maan had mentioned the political group to which his father belonged in a negative way. When his father learned about this, he cut his monetary support. However, this wasn't the first instance of Maan's father interfering with his studies.

During his undergraduate years at the American University of Beirut, Maan had become interested in political science and decided that he wanted to do graduate work in that subject and to study with a particular professor whom he had learned about at the University of Chicago. He applied there, and possibly to some other colleges in the States as well, but was turned down because the schools were saving the places for American GIs when they came back from the Second World War. However, they told him that

if he reapplied in a couple of years, he would have a better chance as more spots became available.

Maan was determined to continue his studies and did not want to wait a couple of years, so he applied to and was accepted at the Sorbonne. Maan's father was a nationalist, and he hated the French. He even told Maan when he was studying French in the private middle and high schools he attended that he did not care if Maan got bad grades in French because he did not care if he was good at the French language at all. Suffice it to say, he was quite upset that Maan intended to go to the Sorbonne.

Following the enactment of the Marshall Plan after the war ended, the American government sent individuals to Damascus to see if they could do something to help Syria get back on its feet. Because of Maan's father's position in that city, he was part of the group that welcomed the representatives of the Marshall Plan to Damascus.

Among the individuals Maan's father was introduced to through his interaction with those representatives was a college president. Through a translator, he told that person about his son not being able to get into a school in America when he wanted to do graduate work there. Because of Maan's father's importance, the college president volunteered immediately, "He can come to my school."

This is how Maan ended up not at the Sorbonne but at Utah Agricultural College in Logan, Utah. Essentially, 'Ali Agha came home from that meeting and said to Maan, "You are not going to the Sorbonne. I've gotten you into a school in the United States." Maan's father had no education beyond high school and he didn't know very much about

colleges at all. Because it was such a patriarchal society, of course Maan could not say no.

Our longtime friend, John Fritzinger, joked about this in his tribute to Maan during Maan's memorial service at Columbia University, asking if those in attendance could imagine how someone with such a worldly background intersected with the milieu of his new surroundings in Logan, Utah, in the late 1940s.

But as it turned out, that was a very important step in Maan's life. He knew English, as he had gone to the American University of Beirut where the courses were taught in English, but he was not that familiar with the basic words you need to get by, such as fork or spoon, among others. So, this experience in Utah gave him an opportunity to really stretch his legs and learn a bit more about the culture here in the States before he started his graduate work in earnest.

Also, he felt very comfortable in Utah because it was a Mormon area with many polygamous families like his own. He felt right at home. Additionally, there were other students from the Middle East who had also ended up there via various routes.

Maan did not give up on Chicago, however. He applied again to the University of Chicago, and because he was already in America, this time he was accepted. After spending a year in Utah, he transferred to Chicago, where he completed his graduate work and got to study with the professor he had wanted to have.

Because his father had stopped his monetary support, Maan had to start taking on jobs to cover his expenses. At one point, he taught dancing at the local Fred Astaire Dance

Portrait of Maan in New York City from the mid-1960s

THE REENTRY OF MAAN AGHA

Studio. This seemed strange to me when he first mentioned it, as I generally had to coax him to dance later in life, but I guess he must have been a good dancer if he was teaching it. I am sure the women he taught did not care about his qualifications; they just enjoyed dancing with him. He also worked at night in a steel factory and drove a school bus for a Catholic school. He told me that the nuns always gave him such wonderful Christmas presents.

Maan had a way of charming the people he met. The age of the person, or their gender, made no difference. He just managed to captivate them. He was also always extremely caring and polite, no matter what. A colleague of mine at The Met who often saw Maan when we attended various large events at the museum once told me that he had the ability to make you feel as if you were the only person in the room.

A story that beautifully encapsulates Maan's true nature happened years into our relationship. One Friday afternoon, before we were to leave for our country house in New Jersey and as I was getting ready to wrap up my day and meet Maan in The Met's garage, where we kept our car, I got a call from him.

"I'm sorry, I'm going to be late," he told me. "I've been held up."

Thinking nothing of it, I said, "Oh that's all right. I have plenty of work to do."

"No. I mean, *really* held up." In other words, he had been mugged.

Maan explained that he had gone to the bank to get cash for the weekend. Someone saw him make a withdrawal from the ATM, and followed him back to his apartment

building. As he was unlocking the door into his building, this person shoved what Maan said felt like a gun in his back and demanded he give them his money.

Remember that Maan had been brought up to be strong. He was not about to give the person his money. However, the mugger then dug into Maan's pockets and ripped his pants right off. Maan ran out onto Lexington Avenue in just his underwear in quick pursuit. As luck would have it, there was a police car driving down Lexington Avenue and Maan flagged them down. I do not remember whether they found the mugger or not, but Maan was safe and sound—although he did need to go back home to get another pair of pants.

As I said earlier, Maan was one of eighteen siblings, twelve of whom are now no longer with us. I haven't met all of them, but the ones I have met have been very warm and friendly to me. I still keep in touch with four of them. These include his half-brother Dureid and his wife, Sawsan, whom I have already mentioned several times and whom I met only once when they came to New York many years ago. It turns out that her father was a well-known Egyptian art historian specializing in the decorative arts of Islamic Egypt and I knew his publications, particularly those on ceramics—a major interest of mine as well. This was really a lovely coincidence.

Maan's half-brother Hussein lives in New Jersey with his wife, Madiha, who is also from Syria. His half-sister Hazar lives in Lebanon, and another half-sister, Najla, in Arkansas. Her husband also is from Syria and is a physician in Little Rock. Hussein, Hazar, and Najla share the same mother, Maan's father's youngest and fourth wife.

THE REENTRY OF MAAN AGHA

What is also really very nice for me is that I have connected as well with some of the younger generations of Maan's family: Hussein's son, Tamer, who lives in New Jersey, and another nephew, Bassem, who is a physician and lives in southern France, as well as Maan's great-nephew Alex, who lives in Montreal. They all keep in touch, which means a great deal to me.

Despite the fact that Frenchtown, New Jersey, and Damascus, Syria, are worlds apart, Maan's family were always so accepting of me. It was just wonderful. I think the fact that I knew a great deal about their culture did not hurt. My being in the field of Islamic art gave me considerably more insight into the Muslim culture than most Westerners possess.

One of the unusual things about my having a life and career that revolved around the Middle East as an adult is that I grew up in a Methodist household, although, despite our going to church as a family every Sunday, and my sister and I attending Sunday school on a regular basis, we were not all that religious.

When I think about my relationship with Maan's family, I am reminded of my father's mother. She was quite an intelligent woman who was a wonderful grandmother to me. She remained active in her church her entire life, playing the organ there for fifty years. She ran a very strict household. On Sundays, the family was focused on church, and no one was allowed to play music or indulge in any other sort of entertainment.

When Daddy was in high school, one of his close friends was Jack Maloney. The Maloneys were Catholic and did not have the same kinds of restrictions on Sundays, so Daddy

would go over to Jack's home after church and the two friends would listen to the radio or do whatever they wanted.

When it was time for graduation, Daddy and Jack planned to join some of their classmates on a trip to Atlantic City—something kids in New Jersey schools still do to celebrate graduation.

About this, my grandmother told him, "Arthur, you're too old for me to tell you what to do. But I just want you to know that Catholics kill people."

My father still went on the trip—and survived—and Jack Maloney ended up being a friend of our family for a very long time. He went on to become president of one of the major banks in New York.

I have always remembered my grandmother's admonition to my father, and I think about it in connection with my marrying a Muslim. In the early 1920s, when my father was in high school, Catholics were thought of in much the same way that Muslims often are today. What would my grandmother have thought of my fascination with the Middle East and my marriage to Maan? I believe he would have charmed her, as he charmed so many people he met. But I do think of this story often because of the discrimination suffered by Muslims that we hear so much about today.

Maan and I started living together within six to eight months of the auction. He had been residing for many years in a rent-controlled walk-up on Lexington Avenue between 70th and 71st Streets, while I was in a modern building on 77th Street between York and the East River. He moved in with me and kept his Lexington Avenue apartment as his office as well as a place to store his collection of antique French furniture.

THE REENTRY OF MAAN AGHA

Especially after Maan, also a heavy smoker, moved in, I knew I had to quit smoking.

Someone dared me to go to Smokenders. Smoking as I did, three packs a day, was an addiction. By this time, even if I ran out of cigarettes at ten o'clock at night, I would go out at that hour and buy another pack. I did not think it would work, but I thought at least I could try.

I am glad I did. Smokenders was fantastic. The program made you very much aware of your habit. You had to attach a piece of paper to your pack of cigarettes. Every time you took a cigarette, you had to mark down that you had taken it, and when. In the beginning, you could not smoke for fifteen minutes before you ate, or fifteen minutes after you ate, or when you were talking on the phone. There were a lot of rules.

With this method, you soon began to get sick and tired of all these rules, and they only got worse as the weeks went on and the markers kept changing. The point was to get you so fed up with the rules and writing things down that the habit would be broken.

The program took me eight weeks to complete and it cost $400, which was a lot of money for me at that time. When I finished, I said to Maan, "Please, you have to stop smoking. Because if you don't stop smoking, I know it won't be long before I'm back to smoking again." I asked him to go to Smokenders, but that was not for him.

"I'm not going to do that," he told me, "but I'll tell you what I'll do. I'm going to sleep it off."

Maan then went to bed for two weeks, only getting up for meals. And when those two weeks were finished, just like that, he was off cigarettes. For the first ten or fifteen years

after we quit, he would have a social cigarette from time to time. It did not affect him. I could never have a social cigarette, as that would have led me right back to smoking.

So now, Maan had come back into my life, I had obtained my PhD, and I had finally put smoking behind me—all in one year, 1978—in addition to beginning what would be a lifelong friendship with Nasser and Hussah. As you can imagine, I was in high spirits.

CHAPTER 9

SIGNIFICANT INSTALLATIONS AND COLLABORATIONS

Throughout my career, I have been honored to have been invited to work on some very exciting installations and collaborations. While this chapter does not include all of the work I have done in this area, the ones featured here are the ones of which I am most proud.

Early in my career, Richard Ettinghausen, who had known L.A. Mayer and helped him build his collection, was consulted when Mayer's foundation wanted to create a museum in Jerusalem in the early 1970s, called the L.A. Mayer Memorial Institute for Islamic Art, now known as the Museum of Islamic Art. Dr. Ettinghausen asked me and my colleague in the Islamic Department at The Met, Marie Lukens Swietochowski, to go to Jerusalem and to help them organize and install the museum.

This was the one and only time that I was in Jerusalem. Of course, I visited all the wonderful major Islamic architectural monuments in that city, which I knew only from books, including the Dome of the Rock, a World Heritage Site that was completed in 691 AD. Its interior bears stunning mosaic decoration. The Al-Aqsa Mosque, adjacent to it, is the third-holiest site for Muslims.

I also went to Bethlehem. Although I am not religious, going to Bethlehem and visiting many other biblical sites as well while I was working in Jerusalem was a very moving experience for me.

In early February 1972, Stuart Silver, the head of the Exhibition Design Department at The Met at the time, and I were invited to Iran as consultants to the Iranian government to advise them regarding their desire to establish a carpet museum in Tehran. Again coming into the picture, Dr. Ettinghausen, who had known members of the royal family for some time, including the Empress who initiated our invitation, wrote a letter of introduction for us. The Empress was very interested in the arts and was a significant collector herself.

This project as presented to us needed much work, and our report to the government, preserved in The Met's archives, indicated that a change in the present plan was required for the museum to be the success they desired it to be. We tried to impress upon the individuals we met during that trip and to whom the report was sent the great potential that they had in this project "to create a single-purpose institution for the study, preservation and exhibition of

SIGNIFICANT INSTALLATIONS AND COLLABORATIONS

one of Persia's most important gifts to world culture."[1] Fortunately, they took our advice very seriously.

Six years later, in February 1978, I went to Iran again. This time I was invited by the Empress of Iran to the official opening of the Carpet Museum of Iran, as were Dr. and Mrs. Ettinghausen and about ten carpet scholars, including my good friend Louise Mackie.

Elegantly attired Persians and foreign dignitaries celebrated the exceptional cultural prestige of Persian carpets in the well-designed installation thanks, in large part, to the work of carpet scholar Dr. Friedrich Spuhler from the Museum für Islamische Kunst in Berlin. The splendid nineteenth-century carpets were triumphs, many given in lieu of taxes to the imperial coffers. However, as many of the renowned sixteenth- and seventeenth-century classical carpets for which Iran was so well known already enhanced Western museum collections, including The Met, the few such carpets on view in the new Carpet Museum of Iran had for the most part been purchased on the 1970s art market.

By the time the museum opened, it was no longer safe for the Shah to be driven through the streets of Tehran (less than a year later, in January 1979, he would be exiled). Thus, every new building that was under construction at this time was to have a heliport, including the museum. This way, he could fly to the opening.

On the day of that opening event, I and the eight or ten international carpet scholars who had helped with the

[1] General Report of Iran Trip (February 2–11, 1972), February 15, 1972, Box 18, Folder 3, Thomas Hoving Records, The Metropolitan Museum of Art, New York.

museum were asked to go into a separate room, as the Shah was coming to thank all of us. We were told to stand shoulder to shoulder while the Shah made his way down the receiving line and thanked each of us in perfect English.

There is a picture of me shaking hands with the Shah. What you do not see in this photo, however, is that over the Shah's shoulder we could see one of his bodyguards with a gun pointed at each one of us in turn as he moved along the line of strangers from another part of the world. As you can imagine, I will never ever forget that.

Being thanked by the Shah of Iran at the opening of the Carpet Museum of Iran. Louise Mackie is on my right.

SIGNIFICANT INSTALLATIONS AND COLLABORATIONS

My trip in 1972 in connection with this project had to be cut short as my father passed away while I was there. This time we spent a week as guests of the government, and the visit was quite memorable.

We were taken south to the lovely city of Kirman, where beautiful carpets have been made for centuries. We went to a rug-weaving facility and watched as the carpets were being created on looms. Kirman is renowned for its carpets, particularly those produced under the Safavid Dynasty, which ruled from 1501 to 1732. Carpet weaving remains one of the city's main industries.

We also spent time in Isfahan on our way to Kirman. Particularly striking in Isfahan is the very large public square, or Meidan, in the center of the city, which was built in the early seventeenth century by the Safavid Shah, Shah Abbas, and which is just spectacular. On each of the four sides of the square is an outstanding building. There is a mosque on two of the sides, the Ali Qapu Palace on another side, and then there is a portico on the fourth side leading to the *souk*, or bazaar. This Meidan has been a World Heritage Site since 1979 and thus was so designated only seven years after UNESCO inaugurated the list in 1972. We were treated royally, and the meals were exquisite. They served us golden caviar, which was traditionally reserved only for the Shah and his family, but they shared some with us—as much as we wanted. Black caviar, which is the best you can buy here, cannot hold a candle to golden caviar. It is extraordinary. I could not help but be reminded of a previous trip to Iran already mentioned when a motorboat in which I was riding on the Caspian Sea was stopped

because it was disturbing the sturgeon that produced this wonderful golden caviar.

Around the time I was beginning my work on the Kuwait Museum, at The Met I was curating the venue of a traveling show organized by Esin Atil, a curator at the Freer Gallery of Art, in Washington, DC. The show was about the art of the Mamluks, a dynasty that ruled Syria and Egypt from 1250 to 1517; the art and architecture of that period are both extremely beautiful. The exhibit ran between November 1981 and January 1982. As the curator for that venue, I very much enjoyed working on that exhibition.

The Amerada Hess Corporation sponsored the Mamluk exhibition at The Met. What would turn out to be an enduring friendship that Maan and I would have with Leon Hess and his wife, Norma, began when I was writing my dissertation prior to earning my PhD in 1978.

During that time, I was visiting late one afternoon with my friend Patti Birch in her New York apartment on Park Avenue. After I had been there a while, she said, "I'm having dinner with Norma and Leon Hess tonight. Would you like to join us?"

"Certainly," I said. I had already met Norma Hess a few times through Patti, but I had never met Leon before that night. Norma's maiden name was Wilentz, and she too was from New Jersey. Her father had been the prosecuting attorney in the Lindbergh trial; Leon founded the Amerada Hess Corporation.

It was a cold winter night, and when we arrived at the restaurant, the Hesses were waiting for us. I quickly checked my coat at the entrance.

SIGNIFICANT INSTALLATIONS AND COLLABORATIONS

"You should also check your briefcase," Leon suggested.

I said, "Mr. Hess, I won't check my briefcase. It has my dissertation in it, which I am working on and I'm afraid to check it."

I think he fully understood and appreciated how I felt about this because he then said to me, "I'll guard it with my life," and kept the briefcase beside him during dinner.

We had a lovely meal and a nice conversation. "Where are you from?" he asked me at one point.

I replied, "A very small town near Flemington."

He then asked, "What town?"

I was so sure no one had ever heard of my small town that I replied: "You would never have heard of it, Mr. Hess. It's so tiny."

He said, "Try me."

So I told him. "Frenchtown."

At that, his face lit up. "I know the tonnage over the Frenchtown bridge," he began, "because I started out driving a fuel truck. I had to know the tonnage on bridges that I was driving across." During the years that I had the pleasure of knowing Leon, I never forgot our interaction that evening and grew to learn very quickly that the humility he evinced that night was only one of his wonderful qualities. As an aside here, when I had completed the dissertation he had watched over so carefully the evening we met, he had Amerada Hess bind its 244 typewritten pages for me in beautiful green leather with its title and my name in gold on the spine.

Over the years, my relationship with Norma developed into a solid friendship. We used to have lunch together

THE LURE OF THE EAST

at The Met every two or three months. At that time, the museum was closed on Mondays, but the staff was there, and the restaurants were open. After lunch, we would invariably spend time enjoying one of the current exhibitions, which we had to ourselves. She was such a lovely person.

Quite surprisingly, Leon also knew Maan from long before he and I became reacquainted. Amerada Hess did a lot of work in the Arab world and needed to have contracts written in Arabic. The company reached out to Columbia University to see if there was anyone who would be willing to help write the contracts in that language, and Maan was chosen to do so.

One of the things that the four of us enjoyed doing together was attending the Jets home games several times each year. Leon owned the team, and he and Norma would invite us to join them together with other family members and friends in their box for lunch and the game. As you can imagine, these excursions were quite special. Their friendship meant a great deal to both of us, as did their support for important initiatives of mine such as the Mamluk exhibition.

For a traveling show like that exhibition, each venue would do something different with the objects when they came to them in addition to providing the wall graphics to explain things as well as the labels.

I decided it would be nice to set the stage for the Mamluk decorative arts being shown by having a series of very large photographs of the stunning architecture of the period displayed on the walls of the galleries. These had been taken by a professor at the American University in Cairo. The photographs were spectacular, all blown up

SIGNIFICANT INSTALLATIONS AND COLLABORATIONS

to maybe three-quarters of the size of a large window—so spectacular that forty years after that exhibition, they are still hanging on the walls of the hallway leading to the Islamic Department offices.

When you are doing an exhibition, you always try to draw the audience into what you are showing them. The New York public did not have the vaguest idea who the Mamluks were, so I thought that in addition to showing their beautiful inlaid metal, glass, and ceramic objects as well as manuscripts, to name just a few of the different mediums, the photographs of the architecture from that period would make a strong impact and help tell the story.

In Chapter 7 I mentioned that Charles Ryder, a designer from The Met's Exhibition Design Department, was assigned to design the Mamluk exhibition, which subsequently led to his becoming the designer who transformed the interior of one of the four museum buildings in Kuwait into the Museum of Islamic Art in the Kuwait National Museum to accommodate Nasser's collection and make certain it was exhibited in the best possible way. He left The Met not long after the Mamluk exhibition closed to work on the Kuwait Museum project.

Maan and I shared so many passions, and over the years, we were invited to collaborate on many exciting endeavors. One such collaboration was with the Barakat Foundation, which nurtures the art and culture of the Islamic world through scholarships it awards to graduate students and funding for academic research and publications in the field of Islamic art and architecture. Maan and I were members of the foundation's Executive Committee, which determined

these awards, from 1990 to 2002. We were invited by the woman who started the foundation, Hamida Alireza, to help in the application review and candidate selection process. Hamida is a member of an important merchant family in Saudi Arabia. Her husband died at a young age, and she established the foundation in his memory. It was wonderful that Hamida wanted to do this to further the study of Islamic art around the world.

I met Hamida through my friend Katie Marsh, so Hamida can be considered another wonderful connection made through Nasser.

Hamida and Maan and I were to become good friends and very much enjoyed our meetings as well as her visits to our country house. She has a wonderful sense of humor. She lives mainly in Jiddah, Saudi Arabia, and has a home in London and also one in California. Her mother was American and her father was Saudi; they met while both were in undergraduate school in California. Hamida and I continue to look forward to seeing one another when we have the opportunity.

Our committee would meet once a year in various parts of the world. One of these meetings was held in Jiddah, Saudi Arabia, in 1999. It was the first time either one of us had ever been to that country. When Maan told Hamida this was his first trip to Saudi Arabia, and thus he had never made the Hajj to Mecca as a Muslim, she told him he should seize the opportunity and plan to go while he was there.

As a Muslim, if you can afford the trip, you are expected to go to Mecca at least once during your lifetime. As we were not there during the time of the annual Hajj, Maan

SIGNIFICANT INSTALLATIONS AND COLLABORATIONS

made what is known as an "Umrah" during that trip. Since I am not Muslim, I could not go to Mecca. In fact, Maan told me that along the road to the city there is a sign at one point telling individuals that if they are not Muslims they must turn back. He was not religious, but as with my visit to Jerusalem, he said just being in Mecca and at the Kaaba was something he would never, ever forget.

I had to be veiled on that trip whenever I was outside a private home. During this first Saudi visit in 1999, I was asked to give a lecture. I did not have to be veiled for that because the lecture took place in a private home, but the minute I went outside, my head and body had to be fully covered. Some things have definitely changed in that country over the years, as the second time I visited there, twenty years later, I did not need to be veiled at any time.

It was so hot to begin with that it was quite uncomfortable having to wear this additional covering. Maan, on the other hand, could, I feel certain, have worn a bathing suit on the street; it would not have mattered.

In another collaboration, Maan and I were invited to serve as consultants for the Islamic Cultural Center in New York. The plan was to build a mosque on Third Avenue between 96th and 97th streets in New York City.

At the time we were invited, in 1984, they were just getting the plans organized and wanted the advice of scholars versed in Islamic art, architecture, and history. We added two other individuals to our group: Oleg Grabar, who at the time was a professor at Harvard and would later be my co-author for *Islamic Art and Architecture 650–1250*, and Renata Holod, a professor at the University of Pennsylvania.

THE LURE OF THE EAST

This invitation also came to me because of my Kuwait connection. The advisory committee for the Islamic Cultural Center was headed by the Kuwaiti ambassador to the UN. He knew about my work in Kuwait, as the museum had opened the year before, and another member of the committee knew Maan and his work, so they invited us both to be consultants.

It was initially a difficult project because the advisory committee had rather definite ideas. They did not understand that all the elements of both the inside and outside of the building had to go together to make a visual whole.

One of the first things that happened is that we had to convince them to change architects. We had to push quite hard to get them to agree to this, but, fortunately, things had not gotten too far along, so we were able to initiate this change. The architectural firm of Skidmore, Owings and Merrill was hired in 1987 to complete the project. Its new plan preserved the integrity of traditional Islamic architecture while assuring that the structure fit into the modern Manhattan skyline. The building is rotated 29 degrees from the street axis so that the *mihrab*, or niche in the wall of the mosque, would face Mecca, toward which Muslims should face when praying.

The committee wanted to invite all the Muslim countries to give gifts to the mosque, and of course, be recognized for the gifts. Our advisory group insisted that we needed to approve the non-monetary gifts to ensure that all furnishings or decorative elements included in the mosque properly fit the aesthetic. The pulpit in the mosque, the decoration of the mihrab, any such gifts they wanted to

SIGNIFICANT INSTALLATIONS AND COLLABORATIONS

give—we had to approve them all. The committee pushed back, but we stood firm in our insistence to vet any gift to be included in the overall design of the mosque. They finally agreed, and as it turned out, there really was not any problem with what was given and what could be incorporated. Additionally, more than forty-six Muslim countries contributed financially toward the $17 million construction cost.

The groundbreaking ceremony on May 16, 1987, was attended by Mayor Ed Koch, along with members of the Muslim community in the city and the diplomats at the UN from Muslim countries.

With Maan in New York City in the fall of 1985

Despite delays brought about because of the Gulf War, the mosque officially opened on September 25, 1991, with a ceremony presided over by HH Emir Sheikh Jaber al-Ahmed al-Sabah of Kuwait. It continues to be one of the city's largest mosques, and it was a privilege to have been able to help guide this important project to fruition here in New York City together with Maan and our two colleagues, Oleg Grabar and Renata Holod.

CHAPTER 10
PUBLICATION HIGHLIGHTS

One of the most exciting and rewarding aspects of my career has been researching the numerous publications I have worked on: thirty-four articles for journals or other scholarly publications and seven books or monographs between 1968 and 2006. I am the sole author of three of these books and the co-author of four. It has been wonderful to have been able to share in print the knowledge gleaned from my object-based research. In this chapter, I will share highlights about what I feel are my most significant publications.

In 1986, I authored the Fall issue of The Metropolitan Museum of Art Bulletin on Islamic glass. I thoroughly enjoyed this project. We have an important, large, and comprehensive collection of Islamic glass. This publication eventually led me to do a small exhibition at the museum four years later on our Islamic glass.

In addition to publishing eighty important pieces from The Met's collection of this glass in that Bulletin—many for

the first time—I was also able to present, in the Introduction, information about three metric tons of glass from the Islamic world recovered from a shipwreck off the coast of Bodrum, in southwestern Turkey, in 1973. This was the first time that this ground-breaking glass find had been discussed in print. As I wrote in that introduction:

> The story of the recovery of this find began in 1973, when a retired Turkish sponge diver directed George Bass, then president and now archaeological director of the Institute of Nautical Archeology at Texas A&M University, to a spot where he had seen sponge divers bringing up pieces of glass. It was located in a natural harbor known as Serce Limani (Sparrow Harbor) situated off the southwest coast of Turkey, just opposite the island of Rhodes. Capable of suddenly and unpredictably becoming a cauldron of swirling winds, this beautiful site over the centuries had been the burial ground for several seagoing vessels.

When the shipwreck was discovered, the Turkish government enlisted the Institute of Nautical Archaeology at Texas A&M University to excavate the wreck. The team was able to ascertain that the ship had sunk around 1025 AD because it contained newly minted, dated coins. It turned out to be quite a consequential wreck for that reason, as it was a time capsule of a single voyage.

PUBLICATION HIGHLIGHTS

In 1984 the director of the Institute, George Bass, invited me to study and ultimately publish the jewelry and glazed ceramics that had also been excavated from this wreck, because he knew of my work in those fields. It was a wonderful experience for me, and it was George who granted me permission to discuss the underwater excavation in the Bulletin's introduction. The volume about this glass that is part of the official publication of this shipwreck was not published by the university until 2009—twenty-three years later. I was grateful that George allowed me to talk about it in my publication on The Met's Islamic glass collection.

Another interesting project I was invited to work on in the late 1980s was the publication of the David and Peggy Rockefeller collection. It was an extensive art collection built over many years, and David wanted to publish the collection privately in several volumes, with distribution limited to family and friends—though it was suggested that the books would be made available to the general public after his and Peggy's deaths.

David lived to the age of 101, passing away in 2017. Rather than making the volumes public, however, after his death there were a series of auctions of the collection over three days at Christie's here in New York, with all of the proceeds directed to a dozen philanthropies David and Peggy had supported during their lifetimes. An article in the *New York Times* confirmed the proceeds of what at the time was the record-setting Rockefeller auction: "In 2018, the treasures of David and Peggy Rockefeller set a high of $833 million for the most valuable private collection sold at auction."[2]

2 Robin Pogrebin, "Christie's to Sell Paul G. Allen's $1 Billion Art Collection," *New York Times*, August 25, 2022.

The Rockefellers had numerous objects from China and Japan, and many European and American paintings and prints. Ultimately, the project resulted in five volumes: *Volume I: European Works of Art* (1984); *Volume II: Art of the Western Hemisphere* (1988); *Volume III: Art of Asia and Neighboring Cultures* (1993); *Volume IV: Decorative Arts* (1992); and then, years later, *Volume V: Supplement* (2015), essentially for the objects that had been collected by David after Peggy's death in 1996.

The other parts of their collection were considerably larger and much more important than that from the Islamic world, but David wanted it to be included. I was invited by him and his curator to work on *Volume III*. I very much enjoyed working with David. Despite his immense wealth, I found him to be quite down-to-earth and an extremely nice gentleman, who through his philanthropic work made such an important impact on others.

I had wonderful experiences studying the objects that he had in his office as well as in their homes in Tarrytown, New York, and in Maine. We flew to Maine in his plane to see the objects that they had in their vacation home. While we were there, he said he wanted to take me to an island off the coast where they had another house. He took me there himself in a large motorboat. We had a lovely time, just the two of us, looking at the objects from their collection housed there. That day he also, very proudly, showed me an area of the island that Peggy had cleared with a bulldozer.

While I never met Peggy Rockefeller, this confirmed what I did know about her: that she was an outdoors person and far more interested in working the land than in a

glamorous social life. She loved clearing their property on her own and driving a bulldozer to do so, something she enjoyed much more than having to go out in the evenings to all the many functions David had to attend.

Peggy was a diehard conservationist. She helped establish both the Maine Coast Heritage Trust (1970) and the American Farmland Trust (1980), as well as serving on the board of various other conservation projects. Like David, and perhaps even more so than David, she was very down-to-earth.

When I asked David how he came to collect objects from the Islamic world, he told me that when his mother got married, around the turn of the last century, she and all of her friends had to have a Persian room in their homes. In essence, they collected these things because it was the fashion. Orientalism was very much in vogue at that time. He said Persian for them did not mean just Persian, it meant Middle Eastern—Arab, Turkish, or Persian. There were about twenty-five Islamic objects in their collection, which he told me had come from his mother and his aunt. He also said that for his first trip outside of Europe, his parents had taken him to Damascus when he was only seven or eight years old.

Years later, I wrote extensively on the subject of Orientalism in an article titled "Collecting the 'Orient' at The Met: Early Tastemakers in America," which was published in *Ars Orientalis*, the principal journal for the field of Islamic art. The entire 2000 issue was to be devoted to the collecting of Islamic art in major American museums, and the guest editor for the volume, Linda Komaroff, invited me to write an article about the Islamic collection at The Met.

I turned her down at first because I was deeply involved in my object-based research at the time, and I thought it would distract me from the projects on which I was currently working and really loved. She did not give up on me, however. About three months later, she came back to me and said, "You've been at The Met for so long. You know the collection so well. Would you reconsider?"

I decided to take on the assignment. During my work helping to develop the new galleries for the collection of Islamic art at The Met, I had already discovered quite a lot of interesting information about who collected the objects we had and how those objects had eventually made their way into The Met's permanent collection. I then set out to determine the circumstances of this fifty- to sixty-year period that had engendered such an interest in the Middle East. This quest led me to the fascinating field of Orientalism, which David Rockefeller had touched on with me, and which had begun in Europe before moving to America.

Maan was excited I was doing this article because, when he began collecting shortly after he came to America, among the things he had collected were European prints of Middle Eastern subjects. Other than American furniture and decorative arts, the only collecting we did together was that relating to Orientalism. The latter shared passion was the direct result of my article. We started collecting from this period, especially decorative arts, as we began noticing both European and American ceramics, glass, and metalwork that were very reminiscent of Islamic pieces, with which we were both so familiar. Because other individuals collecting this material did not have any idea of the Middle Eastern

aspect of these objects, our knowledge of such inspiration did not affect the prices, which remained quite low. We had a wonderful time collecting these objects together until the very end of Maan's life, and I continue to do so.

Long after I retired, Sheila Canby, who was at that time the head of the Islamic Department at The Met, came for dinner one night with her husband, John. During that evening she noticed our Orientalist collection, which was displayed on the shelves in the living room on either side of the fireplace. We started showing them to her and John along with the notebooks we had compiled of comparative pieces from the Islamic world, which had inspired the objects we had collected. Sheila was taken with this whole idea. She and I, both now *curators emeritae,* are hoping to work with the Islamic Department to do an exhibition on this subject. The director of the museum at the time of this writing, Max Hollein, is also interested in this subject. He wants very much to show the museum's collections in new ways, and this fits beautifully with that concept.

One of my first monographs was on Islamic jewelry, which I co-authored with my colleague Manuel Keene. The book was published by The Met in 1983. I organized a small exhibition at the museum to coincide with its publication. During the writing, I decided I wanted to more clearly understand how jewelry was made in order to better explain the techniques employed.

Manuel was already well versed in such techniques and made jewelry himself. He suggested the Kulicke-Stark Academy in Manhattan, which taught the ancient techniques, such as granulation, filigree, cloisonné, and drawing

wire. The school was established by Robert Kulicke and Jean Stark, and was located on the Upper West Side at the time. Kulicke is best known for modernizing frame design, especially for a welded aluminum frame that became known as the "Kulicke frame."

I very much enjoyed learning the ancient jewelry-making techniques, and I think my hands-on experience greatly enhanced my writing.

While I was attending the school, I became friends with one of my instructors, Claire Bersani. Over time, I asked her to make a few pieces of jewelry for me, pieces that I wore on various trips in connection with my work on the Kuwait Museum. Most men don't notice jewelry, but Nasser wasn't most men. He was very interested in jewelry and gemstones. He noticed my jewelry right away, and asked me where I had gotten each piece. When it happened to be something Claire had made for me, I would tell him that and, one day, he said to me, "Do you think Claire would work for me?"

I thought for certain she would, but that they should meet each other first. So, on one of Nasser and Hussah's trips to New York, I arranged for Claire to come to the hotel where they were staying, so I could I introduce them. She and Nasser hit it off beautifully, and she went to Kuwait to work for him for two years. They would call me from time to time from his walk-in vault, where he kept all his gems and jewels and which they had been going through to see what she would work on next. They became quite fond of one another.

While she was in Kuwait, Nasser assigned Claire a driver from Jordan who spoke English, and they ended up getting married. They are divorced now, but remain close.

PUBLICATION HIGHLIGHTS

In 1987, the Walters Art Gallery in Baltimore did an exhibition on the history of jewelry-making through the ages based on their own collection. The museum decided they wanted to bring this history up to the present day and, after hearing about Claire's work for the royal family in Kuwait, asked if a number of the pieces she had made for them could be included in the museum's exhibition. The request was approved, the only caveat being that they could not mention the owners of that group of jewelry in either the exhibition or in the accompanying catalog.

My most important monograph, which I also consider one of the three main highlights of my career, is *The Art and Architecture of Islam 650–1250*, which is part of the Pelican History of Art series and was published by Yale University Press. The fact that I was asked to co-author this monograph at the end of my career allowed me to draw on all of the studying, writing, and work I had done and the experiences I had had traveling all over the Middle East during the approximately forty years I had been in the field up to that time. It provided a wonderful opportunity to organize and express my accumulated knowledge and experience gained during those four decades of learning, work experience, and travel. I was very pleased and proud to be invited to do the second edition of this important work with my co-author, Oleg Grabar. A major figure in the field of Islamic art and architecture, Oleg taught at the University of Michigan and then at Harvard, and ended his career at the Institute for Advanced Study at Princeton. I was to be responsible for the decorative arts and the arts of the book during that six-hundred-year period. Oleg, as

had been the case for the first edition, was responsible for the architecture.

Oleg's co-author for the first edition had been none other than Richard Ettinghausen. Dr. Ettinghausen passed away in 1979, and that first edition didn't come out until 1987, so the final pulling together of the manuscript for publication had to be done by Oleg. We kept Dr. Ettinghausen's name on the second edition, which was published in 2001.

Oleg was very different from Dr. Ettinghausen. He was younger and much more outgoing. Ettinghausen was certainly a popular professor, but Oleg got closely involved with his students. His specialty and mine complemented each other very well. One thing that struck me so positively about Oleg was that he knew what he knew, and he was willing to admit when he did not know as much as he should about something. For example, when he was teaching at Harvard and felt he did not know much at all about ceramics from the Islamic world, he invited me to come and lecture to his students on the subject and Islamic decorative arts in general. To have a professor of his caliber admit that he could learn much more about something than he already knew was indicative of the kind of person he was.

While we worked on the book, Oleg would come to New York from Princeton once a month and we would have lunch in the Trustees' Dining Room at The Met. We would talk over our progress and issues, as well as things we wanted to get the other's opinion about. These lunches were quite important, I think, for both of us, because they gave us the opportunity to exchange ideas and opinions about the things that we were working on and needed to discuss with each other.

PUBLICATION HIGHLIGHTS

Norma Hess and Maan at the party she and her family gave at The Met in May of 2002 to celebrate the publication of the book I co-authored with Oleg Grabar

At the Hess party with Oleg and Vartan Gregorian, who spoke at the event

When our book came out, Norma Hess and her family gave a party in our honor at The Metropolitan Museum of Art to celebrate its publication. By that time, Leon had passed away, but their children attended with their spouses. Norma was so pleased and happy that I was part of this important volume. Included among the guests was Vartan Gregorian, who spoke at the event. Vartan and I had gotten to know each other and worked together earlier, when a special gift was made to Brown University in my honor during his tenure as its president. More on that later.

It was a great honor to work on this project, which took several years to complete. The book has remained the standard textbook for graduate students studying this period of Islamic art and is in its second printing. It has been on the Yale Art and Architecture E-Portal since mid-2020 as well. The work has also been translated into Arabic, Polish, and Turkish.

When the Arabic rights were sold to this book, Oleg found out that ours was the first book on the subject of art history written in English that had ever been translated into Arabic, which was a terrible statistic.

When Maan learned it was going to be translated into Arabic and heard the statistic, he said "I'm going to make sure this is done right, because it's going to be a paradigm for subsequent translations."

So Maan oversaw the translation, which was being done in Doha, Qatar. I was his "secretary," because he did not use a computer. It was published in December of 2012, and Maan passed away in January of 2013, so, happily, he got to see it and was very pleased with the end result.

PUBLICATION HIGHLIGHTS

The last book I wrote (aside from this memoir) is my book on Raqqa ceramics. This one I authored on my own, with two appendices contributed by Aysin Yoltar-Yildirim and Dylan T. Smith. It was published by The Met in 2006.

I went to Raqqa in 2001 and then again in 2002, and spent time in the museum there studying the pieces in that collection dating from the late twelfth and early thirteenth centuries from that important site.

Raqqa, in eastern Syria on the Euphrates River, was an important city in Syria during the early Islamic period and, later, was also known for its ceramic production in the late twelfth and early thirteenth centuries, of which The Met has a large collection, under the Ayyubid Dynasty. This dynasty was the only major Kurdish dynasty in the history of the Islamic world. It was founded by Saladin, who is well known in the West because of the Crusades. If you have kept up with all the problems in the Middle East over the last few years, you will know that Raqqa is one of the places where a great deal of fighting took place.

The book is titled *Raqqa Revisited, Ceramics of Ayyubid Syria* and is dedicated *"To the Kurd in my life, Ma'n Agha and to the memory of my parents."* Maan collected a number of Raqqa ceramic objects. You may recall from Chapter 8 that the two pieces that Maan tried and finally was able to buy at the auction when at first the auctioneer did not see him and subsequently reauctioned the objects were from Raqqa.

Since the publication of my Raqqa book, there are two things that I was asked to do fairly recently regarding my work for Kuwait. One was in connection with the thirtieth anniversary of the opening of the museum. To commemorate

that occasion, a book called *Memories, 30+Years of Collecting*, was published. Since I had been the project director charged with the task of creating the museum, I was asked to write the first "memory" for the publication.

The second was being asked to help develop a website in Nasser's memory. There are six sections on this website, and I advised on the one titled "Culture Maven," which talks about the museum in Kuwait and Nasser's love of collecting throughout his life. Photos of Maan and me appear in that section.

CHAPTER 11

ADVENTURES IN THE MIDDLE EAST WITH MAAN

I recently discussed with my good friend, Louise Mackie, the various international trips I have taken. She asked how many there were, and when I told her there had been a total of fifty-one trips, thirty-seven of which were to the Middle East, she asked, "How many of these trips did you take with Maan?" which I thought was a really good question. I took an inventory and discovered that only about a third of the total trips had been taken with him.

I was a little surprised to learn this, but I realized that many of these trips had been taken before Maan and I got reacquainted. Even after we were together, sometimes there were things I had to do abroad during the school year, when he was teaching. In those cases, I would just go myself. Given the latter, in addition to those taken before he came back into my life as well as those taken since his passing, it made sense that the majority of the international trips I took were without Maan.

During the trips we took together to the Middle East, we often spent some of the time with various members of Maan's family, as previously mentioned. One interesting trip of this nature took place in the summer of 1980. While we were in Syria, one of Maan's cousins, Muhammad Zilfo, asked for my help. He had been a quite well-renowned general in the Syrian army, and I think he and Maan were about the same age. This was the first time I had met him.

When Muhammad learned that I was a curator at The Metropolitan Museum of Art, and that one of my functions was to buy objects for the museum, he thought I must have a good eye and could help him find a bride. He had been married twice before, and both wives had been quite sophisticated and westernized, like him. He thought that since neither of these marriages had worked, maybe it would be better if he were to go back to his roots and marry someone who was both Kurdish and much more conservative.

He told Maan that he had hired a matchmaker who had chosen someone for him in the Kurdish mountains, north of Aleppo. The matchmaker drove the three of us from Aleppo so I could meet her. "Lyn is going to see if she's someone that I should marry or not," Muhammad explained, and also that her family was so conservative that he was not allowed to see her, which is very typical in certain areas of the Middle East.

When we arrived at the woman's home, Maan and Muhammad were welcomed at the front door. I was directed to a side door to do my "research." I read Arabic at the time, but my spoken Arabic was not at all up to par, so I could not

speak with the woman in any great depth. I found her quite polite, however.

After a short while, it was time to go. I was escorted outside to rejoin Muhammad and Maan, who were already back in the car with the matchmaker.

Muhammad asked, "Well, what did you think?"

"She was very attractive," I told him. "She was nicely dressed in a very conservative, simple way. She was very hospitable. She offered me coffee."

And then I told him that she also very kindly offered me a cigarette.

"She smokes?"

"Yes, she smoked. I did not have one."

He then said to the matchmaker, "I told you I did not want anyone who smoked."

Then Muhammad turned to me and said, "We'll look at somebody else tomorrow."

I was not up for that, and I told him as much, "Please count me out," I said. "This is too much like shopping for me and I'm not going to be part of it."

Maan managed to keep a straight face through it all, but Muhammad understood I really meant what I had said and I was not going to evaluate any more potential wives for him. I was not asked to do anything further. And Muhammad never remarried.

In 1982, knowing of my interest in objects produced during the early Muslim dynasties, a colleague in California, Irene (Renie) Bierman, who was a professor at the University of California, Los Angeles, told me about an important find in Yemen. When the roof of the Great Mosque in San'a was

THE LURE OF THE EAST

leaking and needed to be repaired, thousands of very early, fragmentary Qur'an manuscripts were found stashed between the ceiling and the roof. The fact that they were so early that they were written on parchment rather than on paper was extremely fortuitous. Although the folios curled up when they got wet, the parchment was not totally ruined by the water, so they could thus be later conserved and preserved.

Why had all these fragmentary manuscripts been saved? For centuries, Yemen had quite a large Jewish population, and in the Jewish faith, there is a long tradition that, if it has been damaged in any way, you do not throw away any manuscript that might have the name of God in it. You preserve it in a safe place, and where you save it is called a "geniza" in Hebrew.

The Yemeni Muslims adopted this same tradition for these very early fragmentary Qur'ans. When a binding got torn off or a Qur'an manuscript lost some of its folios, and could not be used any more, they stored it in their geniza-like area between the ceiling and the roof of the Great Mosque in San'a, the capital. That is how these thousands of Qur'an manuscripts ended up there.

Not having access to a crane or any construction equipment more sophisticated than a ladder, the workmen making the repairs at the mosque had to get to the roof by going through the ceiling. When they did so, they found this trove.

The Yemenis had not quite known what to do with this discovery, but fortunately, they knew that they *should* do something. They reached out to several professors in Germany for advice. It was suggested that they send the manuscripts to Germany for conservation. When this idea was turned down by the Yemeni authorities, since they did not want

the manuscripts to leave the country, they instead invited a German team that included Qur'anic scholars as well as conservators to come to San'a to work on the find there.

According to Renie, these Qur'an manuscripts were the earliest that had ever been found. This sounded like a fascinating discovery for me to see. Of course, Maan was also very interested in them, being both an historian and a collector of Islamic art as well as a Muslim. We had already planned a trip to Cairo that summer, so we decided to make a visit to San'a part of our trip. Neither of us had ever been to Yemen.

When we arrived, we went to meet with the conservators working on the Qur'an manuscripts, which were just unbelievable. Seeing those ancient pages was an incredible experience. We wanted to take photographs, but they told us that the main religious authority, Qadi Isma'il, was allowing each visiting scholar to take only fifteen pictures. That was not going to be nearly enough. So Maan asked to speak with the Qadi, a request that was granted. This conversation, held of course in Arabic, worked to change the Qadi's mind, and we were permitted to take as many pictures as we wanted.

I thought it would be really wonderful if I could do an exhibition of this important find at The Met, but since I knew that the Qadi was not even allowing the conservation team to take the manuscripts to Germany, where they all of the latest equipment to work on them, I knew that I would not be able to get permission to take them to the States.

During our time in San'a, we took many walks. As we were exploring, we noticed that a number of buildings bore the names of members of the Kuwaiti royal family. When I realized that these individuals had been generously helping

the Yemenis to build schools and various other buildings there, I got an idea that I shared with Maan: "Maybe I could try to have the exhibition at the museum in Kuwait."

I called Nasser and Hussah from our hotel in San'a and told them about the Qur'an manuscripts. Not long after the museum's opening in Kuwait in February 1983, Hussah went to San'a to discuss a possible exhibition of the manuscripts. As the director of the museum in Kuwait and a member of the royal family herself, Hussah secured Qadi Isma'il's permission for such an exhibition, which was held in 1985.

The well-illustrated catalog, titled *Masahif San'a'*, included articles in both English and Arabic, one of which was by Qadi Isma'il. Hussah wrote the preface, and I wrote one of the three articles in English. This groundbreaking exhibition ran for two months. Unfortunately, when Saddam Hussein invaded Kuwait in 1990 and ravaged the Kuwait Museum, all of the catalogs of the San'a show that were still remaining were destroyed. Since then, I have loaned my own copy to the Aga Khan Documentation Center at MIT, and they have scanned a copy of it. It is on their website for anyone who wants to see it. As for the Qur'an manuscripts themselves, their fate given the recent turmoil in Yemen is not yet known.

In addition to my loan of the catalog on the Qur'an manuscripts for scanning, I have also given approximately 4,800 of my slides to the Aga Khan Documentation Center at MIT, which are in the process of being digitized. The Center asked all the scholars in the field of Islamic art and architecture to provide their slides so they could be digitized and made available online. Every time I returned from a

trip, I would catalog each of my slides, directly on the slides themselves, while everything was still fresh in my mind, and they were also grateful for that information.[3]

We had originally planned to stay in Yemen a week but ended up staying a month to take full advantage of the unlimited access to the Qur'an manuscripts that Qadi Isma'il had given us, thanks to Maan's cajoling. Just being in San'a was an extraordinary experience in itself; it is the most medieval city I have ever visited. We learned that until 1962, the gates in the wall surrounding the city were locked every night at eight o'clock and that the despotic rulers would not even allow their subjects to have radios, much less allow them to travel. The people were kept ignorant of what was going on in the rest of the world, so it is not surprising that they were very conservative and wary of foreigners.

One of those rulers had taken many vacations to southern Europe. There he learned about many things, including elevators. His subjects at the time, however, knew nothing about elevators. In San'a, the buildings are customarily four or five stories high. A central spiral stone staircase led to the top floor. This particular ruler installed a secret elevator in his palace.

Each week, on a designated day, he would receive subjects at the palace and meet them at the front door, then invite them to his reception room on the uppermost floor, showing them the stairs. As they climbed, he got into the elevator and "magically" beat them to the top. They thought he was somehow godlike, and revered him as such, which was the plan.

[3] The Marilyn Jenkins-Madina Archive can be viewed online at https://www.archnet.org/collections/1240.

He also pulled another ruse on them. His subjects did not understand the concept of blank bullets, but thanks to his experience outside Yemen, he did. At one celebratory event, he arranged to have guns (loaded with blanks) fired at him, and he did not die. Naturally, again, the people, who did not know any better, thought he was godlike. This is how he kept them oppressed.

In Yemen, chewing the leaves of a shrub called "qat" or "khat" is a national addiction. In fact, we were told that one of the few grounds on which a woman could divorce her husband in Yemen is if he disturbed her afternoon qat parties. One would become quite mellow from chewing this small leaf. They would buy whole branches of the bush, then pluck the leaves and put them one by one into their mouths. We did not want to try it, but we were told it gives a high similar to that from marijuana.

In going through the large number of papers I had kept over many years as I prepared to write this book, I found a letter my mother had kept that I wrote to her and my sister during this trip:

> Maan's family gave us a late farewell party and took us to the airport. We had no sleep at all that night. This is our fourth day here and it is fascinating. One really feels as if one is in the 13th or 14th century. The men all wear turbans, wrap-around calf-length skirts with wide belts into which they stick a dagger. They are very short, wiry people and most of the men are shorter than I. The

women are totally veiled in plain black or black with tie-dyed red, white, and yellow circles. The architecture is fascinating, also, with multi-storeyed buildings, with beautiful stucco decoration. The marketplace is like a fairy land with marvelous herbs, silver jewelry, spices, etc. However, money is starting to change it so I'm very glad we came when we did.

The weather is ideal, about 75 to 80 in the daytime and 65 at night. Sanaa is about 7500 feet above sea level, so that's why the weather is so perfect here in July.

P.S. I am now in the land of the Queen of Sheba. Her kingdom was only about 100 miles from here!

In another letter, I wrote:

I'm still writing from Sanaa, as you can tell from the lovely paper. It is Friday again, and we are relaxing by the pool as everything is closed, this being the Muslim holy day. Since last week, there have been some trials and tribulations with our work but as of Wednesday, we finally got all the permissions we now need to do what we need to do. The bureaucracy in any Middle Eastern country is quite something but as this is the most conservative country either of us has

ever been in, it should not have surprised us that the process of getting permissions was more difficult than usual. We have met several Europeans who work here whom we like very much and who have been very helpful. One of them invited us for dinner on Tuesday and we met a number of other members of the European community. Aside from one's work, there is really not much to do but visit. Thus this community sticks very close together. If we finish our work here in Sanaa, we are planning several side trips to see more of the country. One trip we want to take is to Taiz in the south, where it is much warmer. That would be only for several days.

We have spent most of our time in the library photographing 7th to 10th-century manuscripts and in the museum. We even managed to get into the storerooms. A brother-in-law of Maan's who is married to a sister in Cairo is working here and we have spent three evenings with him so far. He is very nice.

In the spring of 2002, during a trip that also included Kuwait and England, we met our friends John (Fritz) and Linda Fritzinger in Damascus. I had first met Linda in 1963 when we both were working at The Met, and got to know Fritz during their courtship. She left the museum after she and Fritz got married and their son was born. The four of us took a number of trips together over the years, both here and

With Maan in Bodrum, Turkey, in August of 1984

abroad. Fritz was also our lawyer until his retirement. My long and wonderful friendship with both of them continues to this day.

On this trip, we visited various cities in Syria and then in Turkey. In her research for her doctoral dissertation, which ultimately led to a book, Linda had learned about Ma'lula, in Syria, which is the only place on the planet where Aramaic is still spoken. Having grown up in Syria, Maan had heard about Ma'lula, but he had never been there.

On what just happened to be Easter Sunday that year, one of Maan's half-sisters, Hazar, drove us from Damascus to Ma'lula, which we discovered was a very small mountain village. We found a guide there who spoke, in addition to Aramaic, both English and Arabic to take us around. She took

With Maan in the spectacular Todra Gorge in the High Atlas Mountains of Morocco in 1993

us to the main church when there was no service in progress. As we stood at the front of the sanctuary, Maan asked her if she would say something to us in Aramaic because he very much wanted to hear how it sounded.

She said she would be happy to, and asked if we would like to hear "The Lord's Prayer" in Aramaic. So there we were, in the only place left on the globe where Aramaic was spoken, hearing "The Lord's Prayer" in the language of Jesus on Easter Sunday! None of us have ever forgotten that.

Maan and I had so many unforgettable adventures involving work, travel, and spending time with family. We also went on treasure hunts, and purchased and restored an early eighteenth-century colonial farmhouse, to which we retreated on weekends and loved so much. We had a wonderful life together, more of which I will discuss in the subsequent chapters.

CHAPTER 12

TREASURE HUNTING

One activity Maan and I very much enjoyed, mainly just the two of us but also with friends, was treasure hunting. We often spent time in antiques shops and at auctions when we were at our country home (more about that in Chapter 13), and frequently visited antiques shops in New York City and the numerous places we traveled. We made so many wonderful discoveries, with intriguing stories to go along with the items found. Maan truly had such an amazing eye for finding the extraordinary among the ordinary.

Most of my treasure hunts with Maan were in connection with our developing interest in colonial American furniture and decorative arts as well as in the influence of the decorative arts and architecture of the Islamic world on those of Europe and America between circa 1870 and 1920. Maan was collecting Islamic art long before I met him, and as I was collecting Islamic art for The Met, I was involved

TREASURE HUNTING

very little in his collecting in this area as it could have been considered a conflict of interest.

One of my favorite stories of treasure hunting with Maan has to do with the sofa in the living room in our Manhattan apartment. Thanks to the many beautiful pieces of French furniture Maan had acquired over the course of his many years of collecting in New York, we had more than enough to fill the apartment we bought and moved into in 2007, but certain things were lacking—including a sofa.

One day I said to him, "We really should start looking for a sofa. Can you think of any good places where we might find something that would fit with what we already have here?"

"Let's go down to lower Broadway," Maan offered. "I used to go there quite often and I know there are a lot of furniture stores we can visit."

"Do you have any specific place in mind?" I asked.

He said, "Not really. Why don't we just wander?"

That was fine with me. Maan and I liked to wander. Being natural students, we found that wandering allowed us to discover and explore areas we had not experienced before and to learn new things.

We headed downtown and started walking along Broadway south of Union Square, where, as Maan had promised, there were a lot of furniture stores. One that we went into was not the usual furniture showroom. Nothing there was exhibited in the manner typical of furniture stores. Essentially, it was packed with all kinds of furniture, often one piece on top of another. There were about three or four stories of this, plus the basement. Because we had set aside the whole day for this search, we decided to wander around the store and look at everything.

Our Duncan Phyfe sofa as we first saw it in the basement of a shop on lower Broadway

When we got to the basement, we saw a sofa with other things set on top of it. It had bright orange upholstery. We thought this sofa looked quite interesting and took some pictures of it, but we were not sure what exactly it was or if it would fit with everything else we had, so we continued looking. We went to a number of other stores that day, and in the coming days, to keep looking, but the orange sofa had made an impression on both of us.

A friend and former colleague of mine, Stuart Feld, has a major gallery of American art in New York, Hirschl & Adler Galleries. When I first started working at The Met, he was a curator in the American Wing, the department devoted to American furniture and decorative arts. Both Maan and I remembered that maybe a year or so before we saw this sofa,

Stuart had done a show at his gallery on American Gothic Revival furniture, and the orange sofa had what looked like Gothic arches as part of its decoration. I suggested to Maan, "Why don't I show Stuart the pictures of this sofa?"

It is important to note here that the sofa was being sold by this store as an "Irish sofa," and for that reason, it was priced as an Irish sofa. We suspected there might be more to it than that, so I made an appointment to see Stuart. I showed him the pictures and I told him the story.

"Lyn, I think you have found a Duncan Phyfe sofa," he said.

Now the sofa became even more interesting. Duncan Phyfe was a Scottish immigrant and one of nineteenth-century America's leading cabinetmakers. He became famous for his neoclassical furniture and was especially popular in New York, Philadelphia, and the American South. The various characteristics Stuart observed in the pictures I showed him made him believe the sofa was indeed by Duncan Phyfe.

Stuart, wanting to confirm his suspicion, said to me, "I think you should also show the pictures to Peter Kenny."

Peter Kenny was then a curator in the American Wing at The Met and a friend of Stuart's. At the time, I hardly knew him, but over the years, we were to become good friends. He is the type of person who makes everyone brighten up when he enters a room because he has such an outgoing personality, and he was always willing to help anyone, especially young people, who had an interest in American art. He is a lovely person who always puts others at ease. I do not see him too much now because he is retired and lives outside the city, but I very much enjoyed his company, as had Maan.

Stuart explained, "Peter is currently working on a show on Duncan Phyfe for The Met." He also said that in preparation for the exhibition Peter had studied all of the Duncan Phyfe archives but had never been able to locate an example of Duncan Phyfe furniture in the Gothic Revival style. He was certain that Peter would be very interested in seeing this.

As we were talking, Stuart's daughter, who was a partner with him in the firm, came in. He showed her the pictures. "Lyn just brought this to me. What do you think this is?" he asked her.

"Looks like a Duncan Phyfe piece to me," she confirmed.

I left Stuart and his daughter and hurried back home to share Stuart's thoughts with Maan. I then called Peter. "I want to show you some photographs of a sofa we found." I then told him the story of how Maan and I had stumbled upon the piece while wandering around a furniture store on lower Broadway. I continued, "Stuart and his daughter think it may be a Duncan Phyfe exhibiting Gothic influence. The next time I am planning to come to The Met, I will let you know and we can arrange to meet."

"If you have found what Stuart thinks you may have found, I'm coming to you," Peter said. He came to our apartment not long after our call, and after studying the photos we had taken and feeling that perhaps Stuart was correct, arranged to meet us at the furniture store shortly thereafter.

Maan reminded him, "But please remember it's being presented as Irish," knowing well that the store having an understanding of what they were actually selling would greatly impact the price.

The three of us soon met at the store, which Peter aptly described in the lovely tribute he delivered at Maan's memorial:

> It was the kind of shop that brings in container loads of antiques from Europe and displays them in a visually confusing cornucopia of styles and forms on every available surface and wall.

Fortunately, they did not know Peter, since knowing he was a curator in American art would have been another factor that could have influenced the final price. When they brought the sofa up from the basement so that we would be able to see and study it better, Peter recalled how carefully we examined the piece:

> The three of us must have been quite a sight, hoisting the sofa up in crowded quarters, turning it upside down and on end, all in the interest of getting a look at its secondary woods and methods of construction to determine its place of origin.

When we finished our inspection, we casually told the people at the shop, "Thank you very much," and then we left.

We had lunch in a small restaurant nearby and that is when Peter confirmed, "It's a Duncan Phyfe sofa." We were elated to have this confirmation. He added, "You have to buy it, and I'd like to include it in my show."

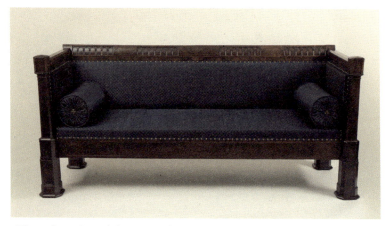

The sofa in the exhibition catalog as it appeared in the show at The Met
Image © The Metropolitan Museum of Art

This was all so exciting to us. But before we could offer the sofa for exhibition, we had to have some minor restoration done to the frame itself, and also to replace the orange fabric. Duncan Phyfe sofas typically have horsehair upholstery, so Peter put us in touch with a source for this in Germany.

We knew an excellent restorer who worked with American furniture and was able to so beautifully and expertly replace the few areas of the sofa's wood frame that were missing. He then recommended someone else to do the reupholstering.

Once the piece was reupholstered, we were able to enjoy it in our living room until it was picked up by The Met for installation in the exhibition "Duncan Phyfe, Master Cabinetmaker in New York," which lasted for five months—from December 2011 to May 2012. When the show closed in New York, it moved to the Museum of Fine Arts, Houston,

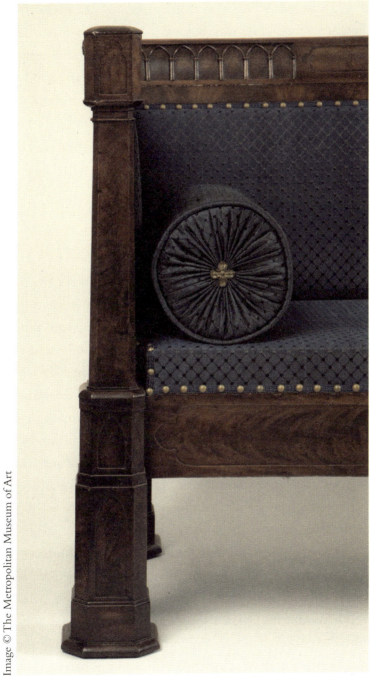

but without our sofa, as we had agreed to lend it only for The Met venue. The sofa is now a Promised Gift to The Met—a legal designation indicating that when I no longer want or need it in my apartment it is to be transferred to the museum to be accessioned and exhibited as part of the institution's collection—and all because Maan suggested we take a walk down Broadway and just wander around. That is the way we found some of the most wonderful things we collected over the years.

Not only did we look for and find major pieces when we were treasure hunting; we also set out to find very small things that most other people probably would not even notice. For example, we realized that at some point one of the previous owners of our early twentieth-century apartment had changed many of the doorknobs. There were several different types that did not necessarily go with each other and did not really fit with the period of the 1916 building.

We were determined to replace those eclectic doorknobs. To find what we were looking for, we spent time visiting shops dealing in salvage and secondhand material searching out doorknobs to find the ones that did fit, as well as to find replacements for several modern lighting fixtures that were also not in keeping with the period.

In both our apartment and our country house, we tried to bring things back to their original condition. And, when looking to buy each of these residences, we searched at great length for something that had not been bastardized, or had been bastardized to such a small extent that it would not be difficult to restore them to their original condition. Thus, we spent time buying not only big things but also very minor

things that most people would never even think about, and we really enjoyed doing both.

In March of 1988, Maan attended the preview at Sotheby's here in New York of an auction of Indian art. He was quite excited about an object being offered and was determined to acquire it. This piece, a textile, was the size of an exceptionally large window. It was described in the catalog as an Indian tomb cover, and the estimate reflected this attribution. Maan knew with certainty that this textile was not an Indian tomb cover because it was decorated with a series of Arabic inscriptions—which he, of course, could read. He had a wonderful instinct of knowing when something was special, and he knew this textile was in that category. But he did not know enough about late textiles from the Arab world to know precisely what made this piece so special. That did not prevent him from buying the textile as an "Indian tomb cover," at a low price.

When Maan collected, he would dig deeply into the origins of the objects he acquired, as he wanted to understand as much as he could about them. As luck would have it, when he acquired the textile, he was teaching an advanced course at Columbia for students of the Arabic language in how to read inscriptions in that language on objects. This is a real art, even for native speakers, because Arabic calligraphy can be, and was, manipulated in so many beautiful and inventive ways for decorative purposes that it often becomes very difficult to read.

One of his students in this class was Karen Kern, who is now a professor at Hunter College. At the time, Maan considered her one of his best students and liked her very much.

He decided to assign his newly acquired textile to her to work on as the subject for a required paper, and she eagerly and diligently took on the task. Through her extensive research she discovered that not only was this textile *not* an Indian tomb cover, or tomb cover of any kind, but that it was a *sitara*, a holy textile that had served as a door hanging inside the Kaaba in Mecca—the most sacred building in the Islamic world.

As can be well imagined, Maan was very pleased with Karen's wonderful discovery. Some years later, because of its importance, he decided to donate the sitara to The Met, in memory of his mother. She had been quite religious, and he knew that she would have been very proud of having a textile that had once hung inside the Kaaba given to and exhibited at The Met in her memory.

The credit line reads:

> Gift of Professor Maan Z. Madina, in memory of his mother, Najiyya Khanum al-Kurdi, 2009

The label reads:

> Sitara, interior door curtain of the Ka'ba Ordered by Sultan Abdülhamid II (r. 1876–1909) Egypt, Cairo, produced in the workshop of Warshat al-Khurunfish; overseen by 'Abbas Hilmi Pasha, governor of Egypt; dated A.H. 1315/1897–98 Black silk ground; pink and green silk/cotton cartouches; silver and silver-gilt couched embroidery

The sitara *as it appeared in the article in* The Metropolitan Museum of Art Journal

The Metropolitan Museum of Art, New York. Gift of Professor Maan Z. Madina, in memory of his mother, Najiyya Khanum al-Kurdi, 2009 (2009.59.1)
Image © The Metropolitan Museum of Art

And further describes the textile thus:

> This Sitara is a very rare example of a curtain that once hung inside the Bab al-Tawba (Door of Repentance) of the Ka'ba, the structure in Mecca that Muslims believe is the house of God on earth. The Ottoman sultan's name, Abdülhamid II, who had the imperial prerogative of ordering the replacement of textiles for the Ka'ba, appears in the fifth line beneath four Qur'anic cartouches. A medallion-like calligraphic composition in the center of the lower half contains the name and titles of 'Abbas Hilmi Pasha, seeking with this offering blessing for him and his family. Such a centralized design emphasizes the political prominence of the local ruler of Egypt, who oversaw production of the textile at the Warshat al-Khurunfish in Cairo and its transportation during the hajj.

The sitara was in fragile condition when Maan bought it and gave it to the Department of Islamic Art at The Met. Thus, it was decided that the object needed to be conserved before it could be exhibited. By the time this work was being done, Maan had passed away.

The textile had to be taken to the Textile Conservation Department at the museum. Having worked at The Met for more than forty years, I knew some of the conservators who were assigned to work on it, and I asked the head of

the department if I could visit from time to time to see the progress on the piece.

The conservator-in-charge at the time, Florica Zaharia, assigned an associate conservator, Yael Rosenfeld, to oversee the work. Yael was to become very interested in the sitara. During my visits to see the progress, I told her what Karen had discovered about the history of the textile and where it had been hung. She was so intrigued, she told me one day that she thought an article should be written about the object.

At this point I reached out to Karen, and she and Yael, together with two scientists from the Department of Scientific Research at The Met, deeply researched and prepared an article on this textile: "The Sacred and the Modern: The History, Conservation, and Science of the Madina Sitara." The history of this piece, coupled with the scientific conclusions that could be drawn, ended up being so rich that a twenty-two-page article was produced, which appeared in 2017 in Volume 52 of *The Metropolitan Museum of Art Journal*.

There is a very large arts and crafts show held each February in Asheville, North Carolina. For a number of years, we would fly down for the weekend during this week-long show and wander through all the booths looking for things we might want to buy while at the same time learning more—which is always a part of the treasure hunt—about the arts and crafts movement, which grew out of the desire to revive handicrafts and flourished between ca. 1880 and 1920 in Britain and America. We would also visit some of the many antiques shops in the area while we were there.

One year, we went to the event with our friends Fritz and Linda Fritzinger. On that trip, we found an object that

was being sold in one of the shops in Asheville. It was a large, tinned-copper basin with an Arabic inscription, and it was very unusual in that many holes had been cut in its base. It was being sold for $125 as a Chinese pot, but we knew it was something quite special. It was a rare colander from either Egypt or Syria dating from the fourteenth or fifteenth century and, consequently, worth so much more. Still, Maan bargained for the piece. Maan always bargained. This was also part of the fun of the treasure hunt for him.

As Fritz recalled in his beautiful tribute at Maan's memorial service:

> I was fortunate to be with them . . . when they came upon a large Syrian metal vessel from the fifteenth century. Its provenance had totally escaped the shopkeeper. As thrilling as their find was, the biggest treat was watching Ma'n bargain for the vessel as if he were going to use it to wash dishes. The combination of his sharp eye, the depth of his knowledge, his love of the chase, and what I can only think was an inborn talent for bargaining—all came together to reward him, and Lyn, with endless pleasure, and to the formation of a number of notable collections.

Maan had a good eye, but he also had good instinct. Another example of a wonderful find thanks to Maan's keen sense of the importance of an object was something he happened to spot at Sotheby's in New York, just as he had

done with the sitara—a group of tiles that only had value to the trained eye. The lot was described as being Ottoman Turkish, from the seventeenth or eighteenth century. Some of these tiles had been glued to a Masonite board, and the rest were stacked in a box close by. Maan bought the lot for quite a low price, Sotheby's not knowing what they had.

At the time, Maan did not know exactly what he had bought either, except he had sensed their importance. After he acquired the tiles, we got to work learning more about their exact origin and where they had been used. When we laid out all the tiles together on the floor, we saw that they formed a beautiful symmetrical design. We could also tell that nine of the tiles in the panel were missing. It was clear that it had originally consisted of twenty-five tiles and, when complete, was approximately 4 feet square.

We also discovered that the panel had come from Damascus, where it most probably had decorated the mosque and tomb complex of Ghars al-Din al-Khalil al-Tawrizi, who died in 1443.

We gave this panel to the Islamic Department at The Met, in both our names, in 2009. Being donated to The Met has been, and shall continue to be, the fate of so many of our prized treasures accumulated over a shared lifetime of collecting.

Since the lot of these tiles had been consigned to Sotheby's by the Kevorkian Foundation, after Maan and I gave the tiles to The Met, I thought to ask Ralph Minasian, then the head of the foundation, if he could look around and see if some of the nine missing tiles were still to be found, perhaps hidden away in one of the foundation's storerooms.

He was able to locate two additional tiles, which he then gave to the Islamic Department.

It is amazing what the Conservation Department at The Met was able to do with these tiles. They mounted them on a large board, carefully and expertly drawing in the missing areas so the viewer is able to see the entire design. It is so beautiful and now resides permanently in one of the Islamic galleries at The Met, with a large label explaining its origin.

CHAPTER 13
LIFE AT THE WYLDS

As I have already shared, my mother was still alive when Maan and I were reacquainted, and she just adored him. They got along so beautifully. She would have loved for us to get married, but it would not happen in her lifetime. She passed away in 1992, and Maan and I didn't decide to get married until 1994. I know she would have been so happy and also, that she was sure my father would have approved of my marrying Maan.

After my father died in 1972, my mother sold our Frenchtown home and moved about eight miles north. When Maan and I visited her there, I spent a lot of time taking him around the area. The part of New Jersey where I grew up was not too far from where Washington crossed the Delaware and is quite a historic area, with many colonial houses I had greatly admired for a long time. We decided we wanted to buy such a country house, something not too far from my mother.

THE LURE OF THE EAST

We started looking for a colonial house that was close to being in its original condition or could be restored back to it without too much effort and expense. We fell in love with a circa 1725 colonial stone farmhouse on twelve acres that had originally been part of a large land grant from Queen Anne to a friend of William Penn's. This charming historical house, located maybe four or five miles from my mother, seemed perfect for us.

It was situated down a long, winding driveway. The exterior was completely covered with white stucco, something that had typically been done to old stone houses in the 1940s and '50s to help keep in the heat. The house had potential, but because we wanted something that was closer to the original, we passed at first. But after giving it some thought, we decided this was the house we wanted. We showed it to my mother. She approved. She told us, "If you like this house the way it looks now, when you're finished with it, I know it is going to be simply beautiful."

We bought the house in 1984 and got to work on the restoration. As charming as it was, the house required quite a bit of work, but we were happy to do it. We started by removing the stucco. The process took time as the stone had to be repointed, but because we both still worked in Manhattan, we were only at the house over the weekends, which meant the stonemason could work all week when we were not there. On the weekends, we had it to ourselves.

Also, the previous owners had thought the front of the house was the entrance facing the driveway, but from studying other farmhouses of the period we learned that was not the case and had to make adjustments accordingly. Unfortunately,

all the electrical wires were placed at what the owners at the time believed was the side of the house, which was actually the original front. We had to work with the authorities to get the lines moved to the back of the house, and quite far to the back of the house. We also installed a new slate roof.

The floors were all original. We just had to polish them. There was also the original winding, enclosed staircase to the second floor. We had three working fireplaces, all of which were original, and we loved "roasting chestnuts on an open fire"—which were simply delicious. That was a favorite winter pastime of ours.

We researched and chose the appropriate paint colors for the inside as well as the outside trim of the house, and we furnished and decorated the various rooms with finds from our many treasure hunts. There were so many shops in the area that specialized in American furniture and decorative arts, plus frequent outdoor auctions with a similar focus. We had a wonderful time learning about this field, which was quite new to us. As we were both lifelong students, we were well up to the challenge of our marvelous new project of furnishing and decorating our own early eighteenth-century farmhouse with things of that period. Of course, we spent a lot of time in the American Wing at The Met and enjoyed getting to better know my colleagues in that department in the process. We also became members of that department's Friends of the American Wing and thoroughly enjoyed the various excursions and meetings planned for the group each year.

We called our house The Wylds, naming it after Nasser and Hussah's country house in England, which I visited

several times while I was working on the museum for Kuwait. Katie Marsh would arrange meetings with specialists working on various aspects of the museum project when I was on my way to or from Kuwait, either at her London office or at the country house in Hampshire.

When the work on our house was nearly completed, we decided we wanted to improve the grounds. We did a lot of exploring around the property to see what might have been there when the house was built—historians treasure-hunting on their property. There were a number of dry stone walls to which Maan would add. He was very familiar with such walls from growing up in Syria. At that time, his father owned villages in the Golan Heights. These villages had numerous dry stone walls, which Maan watched being built and repaired on visits during his summer vacations.

There was a well adjacent to the house as well as a spring on the property. We never used the well but thought there might have been a pond on the property at one time. There was also a swimming pool, which was neither in good condition nor, of course, of the period.

Because neither of us knew anything about gardening or landscaping, we decided we needed help. I asked a friend of mine in New York if she could recommend a good landscape architect for us, and she suggested we call Alice Ireys.

At the time, I did not realize that Alice was a famous landscape architect. I only knew that she had previously worked on the landscaping for houses from the same period as ours, which is why my friend suggested I contact her.

I called Alice early one spring, and we got along very nicely on the phone. However, she told me that this was her

busiest season and that she would not be able to help us until the following year. I then asked her if she could give me the names of a few places in the city where she had done the landscape design so that I could go and look at them in the interim.

Fortunately, we were on the phone so I could not see her face, but it was clear from her tone that she was a bit taken aback by what I had asked her. "Why don't I give you references for some of the books that I have written, and why don't you go and see the Abigail Adams House near you in New York, which I landscaped," she replied.

Maan and I often laughed about this call afterward. It was typical of me to intensely interview someone I was going to hire. I was not going to choose somebody unless I fully researched and questioned them. Through this call we came to realize just how important and famous a landscape architect Alice Ireys was. I was a little embarrassed, but I did not tell her that I was. I thanked her for her time and told her I would look into her books and visit the place she recommended.

Of course, we wanted to hire her and, late the following winter, I called her to ask if she would be able to help us that spring. She accepted.

Alice drove out from Brooklyn Heights, where she lived, to meet us both for the first time and see the house and property. She must have been about seventy-five years old at the time. She was very tall. Her hair was snow white and she wore glasses. We also learned in working with her that she had a wonderful sense of humor.

She drove down the driveway and just as she got out of the car, before saying hello to either one of us, she said, "That

pool will have to go," referring to the pool already mentioned, which neither of us particularly cared for because it was not in the original spirit of the house, and which would eventually be replaced by a one-acre pond.

This was the beginning of what turned out to be a lovely relationship for all of us, one that continued for more than a decade until her passing. We told her we wanted everything she designed to be appropriate to the period of the house, and she understood our vision. We also told her we would need to complete the work in stages, that we could not afford to do everything at once, and she was fine with that. In fact, she worked with us on our landscaping of The Wylds until she passed away, in her late eighties. She did the most beautiful job.

Because she came to us from Brooklyn Heights, she would spend the night whenever she visited the house. In the morning, Maan would make her a Syrian breakfast. Among a number of other delicious dishes, he made hummus and baba ghanouj from scratch. She looked forward to those breakfasts, and he really enjoyed preparing meals for her because he loved watching her face as she savored every bite.

When I began working on this book, I contacted my very old friend Galen Williams, whom I have known since second or third grade. We have stayed in touch all these years. She reminded me that when she had gotten divorced, she lived with me in my apartment for a year until she got back on her feet—something I had forgotten.

She has had an interesting life. One of her major accomplishments was that she founded Poets and Writers in 1970. However, something especially germane to this part of my story came out of my conversation with Galen that day,

that having to do with the fact that at some point she had switched careers, as she had gotten interested in landscape design. She told me that some years ago, around the time that Alice had been working on our landscaping, she had attended one of Alice's lectures. After the lecture, which she had enjoyed thoroughly, Galen approached Alice and told her she was a childhood friend of mine. It would turn out that having been able to tell her this helped Galen to more easily break the ice with Alice.

As the two women got to know each other, Alice started to ask Galen to help on her projects on Long Island's East End, where Galen was based, because Alice lived in Brooklyn and the frequency of necessary trips was beginning to become too much for her at her age.

Galen could not remember exactly when Alice died, so I Googled Alice and saw that Galen is quoted in Alice's *New York Times* obituary, calling her mentor "One of the most prominent landscape architects of the second half of the 20th century."

The most extensive renovation we made to the house itself was to remove an addition that had been poorly conceived and executed. We hired an architect to help design something more suitable in its place. It consisted of the master bedroom and master bath, which we relocated from upstairs in the main house; a small sitting room that we called the winter porch; and, connected to that, the main outdoor porch, which faced a beautiful brick terrace that overlooked the pond Alice designed.

We hired a local excavator to create the pond that Alice decided should replace the swimming pool. While Basil was working on his bulldozer, Maan offered to be his assistant

on the ground and would don his denim coveralls every day and work with Basil until the work was completed. They really became buddies, although the two men could not have been more different—in every way.

Lastly, we hired a stonemason to build a bridge at the far end of the pond. We were heading out on a treasure hunt the day he began his work, and before we left, Maan told him, "This bridge is a very important part of our property because we are going to be looking at it all the time. Therefore, any stone you see in any of my dry stone walls that you think would be perfect for the bridge, you are welcome to take and I will redo that part of the wall."

The stonemason responded, "Well, that's okay. All stones are the same."

Maan stepped away. He was cool, but I could tell he was losing his patience. "If you think all stones are the same, then you do not know much about stones," he said, and fired the workman on the spot. Maan generally had a very long fuse. This short-fuse reaction was not really in his character. However, the stonemason's comment had touched a raw nerve. Maan had seen stones being worked with and utilized since his childhood. He knew how important finding just the right stone was to the walls he was building, and would be to the bridge we wanted to have built.

We then waited until the stonemason we had originally wanted to do this job (the one who had worked on the repointing of our house) became available. He built us the perfect bridge for that spot.

Knowing that we would be spending a great deal of time on the main porch and realizing, as the addition was

The excavator who dug the pond, with his assistant, Maan

being built, just how much sunlight it received, we knew we needed to find a solution for shading the porch well.

The solution we found was inspired by a trip we took to Istanbul in 2001. In fact, Maan and I were in Istanbul together when 9/11 happened. I had a meeting with the director of the Turkish and Islamic Arts Museum that morning. While she and I met in her office, Maan visited the museum. When my meeting ended, I met Maan at a predetermined spot in the museum and he took me to a particular area of the building.

The building that housed the museum had once been an Ottoman palace. It overlooked a beautiful area where sporting events and processions were held. The place in the building Maan led me to was open on one side and overlooked that beautiful area, a place from which the Ottoman sultan and his entourage could view the events below them. But that's not what he was focusing on. In fact, he had sketched the wooden screens that shaded the palace viewing area as well as their metal fixtures. "This is what we should have at The Wylds."

In Arabic these wooden screens are called "mashrabiya." Carpenters in the Middle East were specialists in screens because so many areas of a house had to be screened to prevent the women from being seen. Screens in the Islamic world are not just to shade the light, but to shade the women. So, our colonial farmhouse had slatted wooden porch screens with an Ottoman heritage.

Maan had sketched them in the minutest detail while he was waiting for me to finish my meeting. We took these drawings home to our carpenter. He said, "I can do that," and he did. I still have Maan's drawings.

LIFE AT THE WYLDS

The Wylds was for the most part an escape for Maan and me where we could be alone, just the two of us, so we did not have that many visitors. The house was intended as a getaway because we were both very busy during the week. But we did have guests sometimes, and some notable stories to share.

Maan and I had a Kuwaiti friend who lived very near The Met. I had gotten to know him through my Kuwaiti contacts and, it turned out, a member of his immediate family had been a classmate of Maan's in undergraduate school. He had lived in America for quite some time with his three children.

He asked us one day if he could come see the house that he had heard so much about. We replied, "You're most welcome to come." We invited the children to come as well.

View of The Wylds after the pond, landscaping, and restoration/renovation of our colonial farmhouse were completed, including the wooden screens shading the porch

"I think I'll come in my helicopter," he told us.

There were several places on our property for him to land, but we had to get permission. The town authorities could not believe that we were asking for permission for someone to land a helicopter on our property. Of course, he had a pilot. The pilot's wife came, too. It was a big helicopter. Maan prepared a delicious Syrian meal for all of them, which we enjoyed outside.

Maan spent a lot of time on the grounds building his dry stone walls. I discovered a love for gardening. Alice had provided me with so many places to develop my newfound interest. She put various types of irises around the pond and wonderful rose bushes along Maan's wall by the driveway and flower beds on the terrace. I not only loved to garden but also to arrange flowers in the house, and I would bring them back to the city as well. I had indicated earlier that my mother had been an avid gardener; I never believed I would take to gardening too, but The Wylds changed all that.

We had hired a nursery to help us find the plants Alice planned for various locations on the grounds. Members of the nursery staff came to our property regularly. When one of the young men working for the nursery was going to be married, he asked us if he could have the wedding ceremony at The Wylds. We were very moved that he thought so much of our property that he wanted to be married there, and of course we agreed.

The wedding took place on a beautiful day with perfect weather, so thankfully there was no issue with their holding the event outside. However, they did run into one complication: the long, winding driveway from the main road to the house. It was very narrow and started with quite a big drop.

The limousine driver who had brought the bride and groom and attendants was afraid that he would not be able to navigate the car without incident, so he had to drop everybody off on the side of the road at the top of the driveway.

Our neighbors told us that their daughter, who was about three or four at the time, was watching as the members of the wedding party made their way down the driveway. When she spotted the bride, she shouted, "There's a princess walking down the driveway!" We were not there, so we only heard about this afterward.

As The Wylds was such a special place for us, Maan and I decided this was where we would get married. I told him, "It would really be so nice to be married on Christmas Eve at The Wylds."

He said, "Can you remind me when Christmas Eve is again?"

That house loved to be decorated for Christmas. It was wonderful to be able to have this major event there on Christmas Eve. It was a very small wedding. Just family.

When we finally did get married, sixteen years after we became reacquainted, everybody wondered, "Why in the world did you do so after all this time?"

And I said, "You know, our relationship really couldn't have been better before but it's even better now."

For our honeymoon, we took a train to Williamsburg, Virginia, which at Christmas time is always so beautifully decorated. We had done so much international traveling, it was especially nice to be able to enjoy our honeymoon close to home in an exquisite colonial American setting.

After Maan passed away, I decided to sell the house. Before I put it on the market, however, Hussah asked if she

Our wedding day at The Wylds, Christmas Eve 1994

could see it. Whenever she came to New York, it was only for a short time and mainly for board meetings at The Met. Thus, the time we spent together while she was here included things we both enjoyed doing in the city itself, such as visiting current museum exhibitions and trying new restaurants, among other excursions, and so I had never taken her out to The Wylds. She wanted to see it especially because she knew, of course, that we had named it after her and Nasser's English country estate and had also heard so much about it. When she asked me if we could go, I immediately said, "Of course."

I picked up lunch for us in the city and drove her out one morning. Unfortunately, it rained all that day. She still wanted to walk around the property, which we did, but we could not sit outside for lunch, as I had hoped to do.

I said, "I'll set the table in the dining room, and we'll have lunch in here."

She replied, "I want to eat in the kitchen."

So that is what we did. We had a striking red-painted, very long eighteenth-century country table in the middle of the kitchen with even longer eighteenth-century pine benches placed on either side. I got everything set up, and we had a lovely lunch together there in the kitchen before returning to New York City.

Hussah was the last person I entertained at The Wylds. In looking back on that day, it was a beautiful way to be able to say good-bye to a home that had meant so much to me for so many years, after I had had to say good-bye to the person who had meant so much to me and I had loved so much and so deeply for so many years.

CHAPTER 14

A GREAT TREE HAS FALLEN

Maan lived to be eighty-seven years old. Mercifully, he was not sick for very long before he passed away. After his death, one of our doctors telephoned me and remarked that we should all be so lucky to live as long a life as Maan had lived and in so healthy and strong a condition, and able to do just about everything he wanted to do for most of his long life.

When Maan became very ill and was hospitalized, he had to be intubated. I went to the hospital every day to be with him. He could not talk, but he would write notes to me. One day, he wrote, "If I should die, I want to be buried in Frenchtown, next to your parents."

This was surprising to me. We had talked about so many end-of-life subjects over the years, but one thing we had never spoken about was where we wanted to be buried.

Maan never knew my father, but he and my mother got along so beautifully, and he really loved the area

where our country house was located. Whenever we went to Lambertville or New Hope, or other places along the Delaware River on our many treasure hunts, we would go by the cemetery in my hometown. Right next to Mother and Daddy, there was space.

It never occurred to me, however, that he would want to be buried there. After all, his immediate family is buried in Syria. I would not have known that he did not want to be buried in Syria had he not had the presence of mind to let me know his final wishes.

Of course, when his time came, I was devastated. If the decision had not already been made for me, I do not know how I could have decided where to bury my beloved Maan. But again, this was a beautiful example of Maan being Maan. As sick as he was, he understood that he needed to tell me because he knew I would not be able to decide. Even in his terminal condition, that special part of him remained strong.

Throughout my life, rising to the occasion had been my forte. Here was one instance where I would not have been able to, and where Maan carried me through. When I die, I will be buried next to him. My name is already on the tombstone.

Maan had a small, private funeral; a much larger memorial service was held in the fall of that year for his many dear friends and admirers. He touched the lives of so many, and he left an extraordinary gap in our lives we will never be able to fill.

Friends of Maan's and mine who live in our building, Kevin and Hatice Morrissey, sent me a moving email on

Maan's passing. Hatice is originally from Turkey, and we had all bonded over our Middle East connection soon after we met. The email contained sixteen photographs Kevin had taken on the grounds of their country home, each of which had a beautiful and touching caption. One of these captions read "A Great Tree had fallen" and another, "Great trees cast long shadows in the snow."

That was our Maan. A great tree, now fallen.

Many attended Maan's memorial service, held in beautiful St. Paul's Chapel at Columbia University that September. I do not remember much except that it was a lovely fall day. I did not have anything to do with the service, except for inviting the speakers to make their moving tributes to Maan. I sat in the front row and did not mingle very much with those who attended, either at the service or the lovely reception that followed.

Maan's great-niece, Nadine Shubailat, delivered a wonderful tribute at his memorial service. In it, she shared information about the historical background of his family as well as information about his early years that those who knew him in New York may not have known. She called him *Khalo*, which in Arabic means "maternal uncle," although he was the brother of her maternal grandmother.

In her tribute she shared the sentiment of Hussein, Maan's youngest half-brother:

> Ma'n was our agha. God gave him everything. God gave him beauty, a special personality, knowledge, and independence. He lived his life his way, amidst the things he loved—his

antiquities and beauty. He was always and will always be our agha.

Later, in November of that year, The Met held a lecture in Maan's memory. The speaker, Nasser Rabbat, is a professor of Islamic art at MIT, and Director of the Aga Khan Program for Islamic Architecture. Nasser is from Damascus and had been a childhood friend of several of Maan's nieces. He spoke about a subject in which Maan would have been very interested, in front of a large, rapt audience comprised of many of Maan's friends, colleagues, and family members.

People of all ages were touched by Maan. My sister, Carole, and her husband, John, always hosted Thanksgiving, inviting Maan and me, a paternal cousin of Carole's and mine, and John's daughter and her husband, as well as their two children. John's grandson, Luke, happened to share a birthday with Maan: February 17. Luke liked Maan very much.

When he was about six or seven, Luke asked for something during Thanksgiving dinner. Whoever he asked gave it to him, but his mother said, "Luke, when you ask for something and someone gives it to you, you really should say, 'thank you.'"

Luke did not like being scolded in front of everybody, but Maan found a way to make him feel better. He told Luke, "If you're a good boy for the rest of the meal, I'm going to show you how to write 'thank you' in Arabic."

Well, Luke was as good as gold for the remainder of the meal. Afterward, Maan showed him how to say and write *shukran* (thank you) in Arabic. He then showed Luke how to write his name, which in Arabic is Lukas. Luke was over the moon learning this.

When I was going through Maan's papers after he passed away, I found a card Luke had sent to him for their shared birthday several years earlier saying, "Shukran," written in Arabic and signed "Lukas," also written in Arabic. Maan had happily saved the card.

We continued to have Thanksgiving dinner together after Maan passed away, but of course, it was so very different without him. That first year, after dinner, Luke asked if he could be taken to Maan's gravesite. Maan had made such a big impression on Luke, as he had on so many he had encountered over the years.

After Maan's passing, I was reminded of a poem by the thirteenth-century Persian poet Rumi. It is so simple and beautiful and it encapsulates so well my feeling with Maan no longer here with me:

> Goodbyes are only for those who love with their eyes because for those who love with heart and soul there is no such thing as separation.

I have placed a copy of this poem in the corner of a framed and wonderful photo I have of Maan on my desk.

A GREAT TREE HAS FALLEN

*Portrait of Maan that I took during our trip
in the summer of 1980*

CHAPTER 15

KUWAIT REVISITED

Hussah was in New York when Maan passed away. As a member of the board of trustees of The Met, she was in town for a board meeting. Of course, I had to cancel the plans we had made for while she was here.

She and Nasser could not have been more gracious and thoughtful at this time. She told Nasser of my loss immediately. He called me right away and said, "We want you to come to Kuwait when you're feeling that you can because we want to help you through this."

"I don't feel I can come right now," I told him, but I did go about two months later for about a week.

They were both just wonderful to me during my visit. Katie Marsh was also in Kuwait at the time, and she and I went on Nasser's plane to Doha for one day to see the Museum of Islamic Art that had recently opened there.

I did not know how everything was going to work out because I was not at my best during that time, but the trip

pushed some of the sadness off my plate for those few days. It helped me start the long healing process, and I thanked them both profusely for that. What truly wonderful friends they both were to do this for me.

During that trip, I was able to be a part of a special tradition in their family. On the same day every week, they host a family lunch that includes anyone in their immediate family who is in Kuwait and able to come on that day.

Because I happened to be there on the appointed day, I was invited to join them for this wonderful family lunch. Among their guests that day was one of their sons, along with his wife and their several children, one of whom, Hamad, initiated a conversation with me.

Hamad was about seven years old at the time. His father had told him that I worked at The Metropolitan Museum of Art, and he approached me during the lunch, telling me, "I love The Metropolitan Museum of Art."

I replied, "Oh, Hamad, I'm so glad to hear that."

He continued with, "I want to be an archaeologist."

I told him, "I think this is a wonderful idea."

And then he said, "I know how many dead people there are at The Met."

That, of course, caught me completely off guard. "Now Hamad, what do you mean by that?"

"I counted the mummies," he told me with confidence. "There are thirteen of them."

He was quite serious when he told me this, and I struggled to keep a straight face. He was smart and adorable, and it warmed my heart to see this very young man have so much passion for something that had also excited me at such

With Sheikha Hussah in the Kuwait Airport embarking on our December 2019 birthday trip

a young age, and that continued throughout my life. I hope he holds on to his passion as well.

Since that trip, I have been back to Kuwait three times. One of these trips was a birthday celebration. My eightieth birthday was on January 2, 2020, and Hussah had suggested, "Why don't we take a birthday trip? To celebrate my seventieth and your eightieth?"

Hussah does not know exactly what day she was born because a date of birth was only recorded for males at that time. However, because she knew of various events taking place in Kuwait around the time she was born, she was able to determine that her birthday is in either late December or early January. Our birthday trip took place between December 15 and 23 in 2019. It takes the better part of a day to get to Kuwait and to get back as well, so we spent about a week together.

After I arrived, we spent a little time in Kuwait, and I got to see Nasser and their children. Then we flew to Doha, Qatar, where we were greeted and entertained by several sheikhas of the Qatari royal family. Because Hussah broke a glass ceiling as the first sheikha in the Gulf to be the director of a museum, they look up to her, and, I believe, view her as a mentor. They took us to their museums, and although we were not wined because there is no drinking, we were certainly dined. We flew back to Kuwait that night.

The next day, we flew to Abu Dhabi to visit the Louvre Abu Dhabi. This time we were by ourselves, and we had a wonderful time. I was very happy to see how beautifully installed the museum was and how well attended, and I am so grateful I had the opportunity to see this highly acclaimed museum so soon after it had opened.

The following morning, we flew to Dhahran, Saudi Arabia, which is in the extreme eastern part of the country. A new museum had just recently opened there, the King Abdulaziz Center for World Culture. It was a beautifully designed building, but the Saudis did not yet have a collection of their own to put in it. Instead, they asked several Western museums if they would create a series of small exhibitions to inaugurate the new building. Among the museums they asked was the Los Angeles County Museum of Art (LACMA), which put together an exhibition of Islamic art, a third of the objects of which were from Maan's collection, which I will discuss in greater detail in Chapter 16. He would have been so proud to see his pieces exhibited in Saudi Arabia. We spent the day in the museum, and I was really quite amazed, as I had been with the Louvre Abu Dhabi, to find it so very well attended.

After completing our visit to the Dhahran museum, we were driven to Bahrain, an island off the eastern coast of Saudi Arabia. I had been there once, more than thirty years prior, in 1986. Abdul Latif Kanoo, a member of an important merchant family in Bahrain, had wanted to create a museum in Manama, the capital, called Beit Al Qur'an (House of the Qur'an), to house his own collection of Qur'an manuscripts. He wanted my advice on how to begin planning this museum. I had first met him at an Islamic art seminar in Farnham, England, in the summer of 1985. The following February, I believe it was he who arranged that I be invited to Manama for the annual meeting of the Bahrain Archaeological Society, and it is while I was there that he and I spent a good deal of time discussing the plans for his museum.

As an aside, while I was there, I was told that one of the sheikhas in charge of museums wanted to meet me, and a driver was provided for me. Unfortunately, the driver did not know exactly where the sheikha's office was, and I was not able to speak very good Arabic.

After some time, I spotted a soldier in a little lean-to. I asked the driver to stop because I thought this soldier might know where this member of the royal family had an office. He complied and I got out. As I walked toward the soldier, I was planning how to ask him in Arabic what we needed to know. Except as I got closer, I saw that he had a name tag over one of his pockets indicating that he was, most probably, an American. I did not know until that moment that the US Navy has an important base in Manama. Of course, he was as surprised to see me as I was to see him.

Now, back to our birthday trip. We arrived in Manama late in the day after our drive from Dhahran. As had been the case in Doha, we were greeted, guided, and entertained by several sheikhas who were principals in the museums we visited and looked up to Hussah as a mentor. They arranged a wonderful dinner for us the day we arrived. The next day, we were taken to see lovely old houses and to tour the new museums that had been built since I was last there. I feel quite certain that the sheikha I ended up finally being able to see on my first trip to Manama in 1986 was, most probably, one of the sheikhas who entertained Hussah and me during our visit to Manama more than three decades later.

We flew back to Kuwait that night, and the next day, I flew back to New York. It was a birthday trip I will never forget. We had such a wonderful time.

The one sad part of that trip was that during this time, Nasser was very sick and approaching the end of his life. However, I was happy to see that his enthusiasm for and great interest in the arts had not waned at all. He was also quite pleased to see my reaction when, just before I left for New York, he handed me some emerald crystals wrapped in Kleenex and told me, "Give these to Claire and tell her to make something for you." As you may recall, Claire Bersani was my jewelry instructor, to whom I had introduced Nasser, and who had subsequently worked for him in Kuwait for several years and continued to do so after returning to the States.

About six months later, in early July 2020, Nasser was in New York for medical treatment. They have a house in New Jersey, and he and Hussah invited me to come for lunch. I wore the bracelet Claire made for me with the emerald crystals, knowing that he would want to see what she had created. After I received a big hug and kiss from him, he noticed my bracelet immediately.

"Is this what Claire made for you?" he asked. "Did you tell her what to do?"

I replied, "I just told her that I wanted the crystals to be made into something that would be conservative enough that I could wear it often."

"She did a beautiful job," he said.

Claire played a special role in their lives, and they in hers.

The last time I saw Nasser, in late August 2020, just a few months before his passing, I got a call saying he was back in New York for further treatment and he wanted to visit the Islamic galleries at The Met while he was here. This was quickly arranged and I, and the department head, Navina

Haidar, took him through the galleries that he had not visited in many years. Navina even managed to arrange for the director, Max Hollein, to stop by while we were there so he could meet Nasser.

It seems very fitting, indeed, that the two visits Nasser and I made together to the Islamic galleries at The Met—the first in 1978, when we met, and the last in 2020, just before he died—would be the bookends for our forty-two-year friendship and collaboration.

However, our relationship is not only bookended by those two meetings at The Met. Before Nasser passed away, Hussah endowed a chair, in his name, in the Islamic Department at The Metropolitan Museum of Art. Navina Haidar now holds that chair. Going forward, as you will see, a part of each of our legacies will also be intertwined at The Met with chairs in its Islamic Department—one in Maan's and my name, and one in Nasser's.

I recently had the opportunity to return to Kuwait. In the fall of 2022, Hussah invited me to speak at a conference being planned for February 2023 to celebrate the fortieth anniversary of the opening of the museum I had helped them create—an invitation I happily accepted. She wanted me to give the introductory lecture for the conference, providing the background on how the museum came to be.

The conference, sponsored by the National Council for Culture, Arts and Letters, was titled "Art and Diplomacy." Because the museum is still being renovated, this subject had been chosen to convey the role various exhibitions from Nasser's collection played in Kuwaiti diplomacy as they were sent on loan to major museums in a number of countries

following the Iraqi invasion—before and while the renovation of the museum building was undertaken. Six of the eight speakers were Kuwaiti ambassadors who had served in some of those countries. The conference was well attended and well received by the press. It was written up by both the *Kuwait Times* and the *Arab Times*, both English-language newspapers, and I am in the photograph published in the former, along with the moderator and three of the other speakers.

Hussah arranged many other events for me during my approximately week-long stay in this, my fifteenth visit to Kuwait. However, being able to spend my last full day there with just the two of us, after having not seen her in two and a half years, was particularly special for me.

CHAPTER 16

OUR LEGACY

I have led a fascinating and wonderful life, with incredible support from so many. Maan and I were able to accomplish a great deal, and we were always grateful for what we had. Because we received so much from so many, I am very fortunate to be in a position to give back. Maan felt the same way. We have no children, so it is wonderful that we are able to share what we have with others. In this chapter, I will speak about our legacy and how important giving back has been to us.

In 2009, Maan was made Fellow for Life of The Metropolitan Museum of Art for all the objects he had donated to a number of the institution's departments over many years. However, his Islamic art collection, consisting of more than eight hundred objects, did not go to The Met. Maan had offered it to its Islamic Department first, but due to its already large, important, and comprehensive collection, they were interested only in those objects in his

collection that filled gaps in their own. He chose to sell it to the Los Angeles County Museum of Art (LACMA) so the entire collection could be kept together—an acquisition that was discussed in the *New York Times* by Rita Reif in her article titled "A Professor's 800 Pieces of Islam."[4] The day the article appeared, Norma Hess called to tell me how much she had enjoyed it, but that she felt there was one thing missing: a photograph of Maan.

LACMA's collection already included many objects from both Turkey and Iran. Although Maan's collection was quite comprehensive, objects from the Arab world were dominant. Thus, adding his to their existing collection made LACMA's that much more comprehensive and therefore, important.

After he sold the collection, we decided to establish a trust from the proceeds with two specific goals in mind: supporting departments of Islamic art at art institutions and making it possible for deserving individuals from the Middle East to pursue a higher education and/or further expand their horizons.

Maan had attended International College, the private school affiliated with the American University of Beirut, starting in the sixth grade, and did his undergraduate work at the university as well. He always felt the opportunity he had to study at the American University of Beirut greatly expanded his horizons and transformed his life, and he wanted to provide the same opportunity to deserving students from the Middle East who could not afford it otherwise. For that reason, one of the beneficiaries of the trust is the American University of Beirut. Each year, after my

4 Rita Reif, "A Professor's 800 Pieces of Islam," *New York Times*, May 12, 2002.

passing, one undergraduate scholarship and one graduate fellowship in the humanities will be granted in Maan's name to a deserving student of Syrian or Palestinian origin.

Another recipient of the trust is Columbia University, where he served as a professor for forty years, retiring in 1998 as Professor Emeritus. This gift, to the Middle Eastern, South Asian and African Studies Department—Maan's department—endows the Maan Z. Madina Visiting Scholar Program. Each year, a scholar of Middle Eastern origin who is a professor at an institution in the Middle East and whose work is deeply grounded in the history of the Arab world is to be chosen by the department's faculty to come to Columbia for one week, to lecture and to meet and interact with its students and faculty. The first Madina Visiting Scholar was welcomed during the 2016–17 academic year.

I was so happy to hear from various members of the faculty of the department involved that this is one of the highlights of their year. When I pass away, the program will be expanded in alternate years from one week to the entire academic year.

Another beneficiary of the trust is The Metropolitan Museum of Art, where, at my passing, there will be an endowed curatorial position in the Department of Islamic Art, focusing on the period up to 1250, which was not only my main interest in the field of Islamic art but also Maan's. The recipient of this chair will be known as the Marilyn Jenkins-Madina and Maan Z. Madina Curator of Islamic Art, briefly referenced in Chapter 15.

For a number of years, one of my responsibilities at The Met was to train a group of the museum's volunteers to take

visitors through the Islamic galleries. We have a very large volunteer program at The Met, so curators in the various departments were tasked to train them. I very much enjoyed doing this, as it not only gave me the opportunity to get to know some of the volunteers but also to make certain that, through their training, they would be conveying the correct information to the museum's visitors about the objects exhibited in our galleries.

One of the volunteers I trained and was to develop a special relationship with was a lovely person named Diane Burke, fondly known to her friends as "Didi." She was always beautifully dressed and was such a popular guide that whenever important visitors arrived at the museum and had gone through the director's office, she was most often asked by the administration to take the visiting dignitaries on a tour of the museum. She gave regular tours in other departments as well, but she seemed to be particularly interested in those she gave in the Islamic Department.

Didi's husband, Jim, was chairman and CEO of Johnson & Johnson during the Tylenol scare in 1982. For those unfamiliar with the event, that fall, someone had tampered with a number of bottles of Extra-Strength Tylenol, filling them with cyanide and placing them back on the shelves for sale around Chicago. Seven people were killed after ingesting the poisoned Tylenol.

As chief executive, Jim immediately took action. He formed a strategy team to both inform and protect the public, and to save the product (and possibly the company) from going under due to this horrible event. After Johnson & Johnson issued a warning to neither buy nor consume any

more of the product until the mystery could be solved and properly dealt with, they recalled all the existing product from stores across the entire United States. They tested the Tylenol and resealed it in tamper-proof packaging before putting it back on the shelves.

Didi was very proud of how he had handled the situation and happily explained that his solution was later taught at Harvard Business School—essentially as an example of how to best tackle a problem in business as opposed to other examples of what one should never do when tackling such a problem.

Although I did not know Jim as well as I knew Didi, we got along well, as did he and Maan. The four of us used to go out for dinner quite often. We would also join them for an evening at the Metropolitan Opera several times a year. Johnson & Johnson had a box there, and Jim and Didi would invite us to join them and six or eight other friends for dinner at Lincoln Center followed by the performance. As you can imagine, we treasured those evenings.

In 2001, Didi and Jim gave a million dollars to the Department of Islamic Art at The Met, to be used solely to purchase works of art in my honor. This was a wonderful and very generous gift. It specified that the purchase fund could, first of all, only be used to fill a gap in the collection—that it could not be used to duplicate anything we already owned. Second, any object purchased with it had to be in my field of expertise and I had to be able to sign off on it. Everything that is bought with the fund bears a credit line that states, "The James and Diane Burke Gift, in honor of Dr. Marilyn Jenkins-Madina." To date, six outstanding objects have been bought for the Islamic Department with the Burke Fund.

Adrienne Minassian was a dealer in New York whom I met through Dr. Ettinghausen. She dealt in manuscripts, miniatures, and the decorative arts from the Islamic world, and sold objects to major museums with collections of Islamic art as well as to private collectors, including Maan. She and I got to know each other during my visits to her apartment looking for objects to buy for The Met.

Adrienne's father, Kirkor Minassian, was originally from Turkey, became a dealer in Paris, and later, brought his business to New York. I wrote about him in my previously mentioned article, "Collecting the 'Orient' at The Met: Early Tastemakers in America," as he was an important dealer during the period between 1870 and 1930 covered in that article:

> Kirkor Minassian, hailing from Kayseri, Turkey, does not seem to have conducted excavations but rather to have acquired many of the objects in his collection through extensive travels. The foreword to the catalogue of a loan exhibition in May 1925 at the Wadsworth Atheneum observes that Minassian had come from Paris a decade before (actually in 1916), 'bringing with him . . . part of the large collection which he had been years in making. He was one of the earliest connoisseurs to gather the pottery, miniatures, textiles, bronzes and other objects from Persia and the Nearer Orient where he has traveled extensively.'

When her father died in 1944, Adrienne took over the business. By the time I met Adrienne, she was operating the business from her apartment as well as from a storage unit where she would also meet customers to show them objects.

She and I developed a nice relationship. Of course, she also liked Maan, and she adored Dr. Ettinghausen.

Adrienne must have been in her sixties and seventies when I knew her, and had a lovely apartment on 57th Street in Manhattan. She was sort of still living in the first half of the twentieth century. She had one sister who was married and I believe lived in Brooklyn, and another sister who lived with her. Adrienne had never married.

I think I may have been a window into another world for her, because she grew up in quite a conservative household. I do not know how much dating she had done, if any. I remember one time she said to me that she always had wanted to go to a ball.

"Have you ever been to a ball?" she then asked me.

It seemed like such an unusual question. Assuming she just meant a large dance, I replied, "Yes." She really did not get out much, and lived a cloistered life.

Throughout the years we knew each other, I had no idea how much I meant to her. It was not until her death in the late 1990s that I realized in what high regard she held me. I learned that in her will she had bequeathed a monetary gift in my honor to Brown University, my alma mater, which was ultimately to become The Adrienne Minassian Professorship in Islamic Art and Architecture in Honor of Marilyn Jenkins-Madina '62. This chair in my name would

mark the beginning of the study of this important field of art history at the university.

I was so surprised and humbled to find out that she had given this money to Brown in my honor. She had also outlined in her will that I should be the person to go over all of her remaining objects and decide to which institutions they should be donated.

Because of her long relationship with The Met, as well as my own, the Department of Islamic Art at that institution was given first choice. However, I specified that only those objects that filled a gap in that collection could be chosen. She also had had dealings with the Freer Gallery of Art in Washington, DC, so I gave its curators the opportunity to make their selection once The Met had done so—again with the caveat that the choices had to fill gaps in that collection. I designated the remaining objects to Brown University to provide important support for the study of Islamic art there, as it did not own any such objects at the time.

This bequest also brought another much-admired person into my life, Vartan Gregorian, whom I previously mentioned had attended, and spoke at, the party Norma Hess gave at The Met after the publication of the book I co-authored with Oleg Grabar, *The Art and Architecture of Islam 650–1250*. Vartan was the president of Brown at the time of Adrienne's bequest in my honor to the university. He had previously served as head of the New York Public Library and, after his tenure at Brown, became head of Carnegie Corporation of New York. My relationship with him grew over the years, and I valued his friendship. Maan and I would also go out for dinner with Vartan and his wife, Claire. Vartan had gone

to high school in Beirut, and Maan had gone to middle school, high school, and college there as well, so they bonded over that. Additionally, Vartan was born in Tabriz, Iran, and he did not know many people in New York who had been to his hometown. So, we bonded over that as well.

After Adrienne's gift, I was asked by Vartan to be on an advisory committee at Brown consisting of four or five others from the Art History Department and tasked with deciding whether or not to start a museum at Brown. After a great deal of thought and many meetings, we concluded that it did not make sense for the university to undertake such an endeavor, as the Rhode Island School of Design, right down the hill, already had the well-established Rhode Island School of Design Museum.

CHAPTER 17
CLOSING THOUGHTS

As the coda to my story, I would just like to share this. While there is no one formula for living a life fulfilled, there are things that have come up time and again as I have reflected on the events of the past eight decades that I believe have helped me to live a life I have been proud of and would like to accentuate here.

One of these, which I have talked about a great deal in this book, is the importance of education. I feel blessed that I was able to go to Brown, thanks to my wonderful parents, but to also find a way to continue my education when they did not want me to do so—to pursue an MA, which Brown helped me to do, and then my PhD, which The Met very kindly underwrote when I took only one course per semester. There are always opportunities to be found to help someone pursue an education if one looks hard enough. It broadens one's horizons and enhances one's perceptions immeasurably. An education is one of the few things that no one can take away from you.

CLOSING THOUGHTS

There is also what I feel is the great importance that travel plays in one's education. What I learned in traveling the world not only gave me the ability to better understand my field than would ever have been possible by simply reading books and looking at photographs; it allowed me to actually experience the culture I was getting to know in the classroom. It was an essential component of my education in Islamic art and architecture. Traveling and experiencing other cultures makes you look much more deeply at things and gives you greater empathy, something so important in today's world. My numerous trips allowed me to better comprehend the beauty of the Middle East and its culture, and the fine character of its people. I hope I have been able to provide a brief glance into that rich world and arouse curiosity about it in others, perhaps luring them to the East as well. No matter your chosen path, however, traveling and experiencing different cultures will expand your knowledge immeasurably. Observing things for yourself will give you a new way of seeing things.

I have mentioned that my parents instilled confidence in my sister and me, for which we are both very fortunate and grateful. This is not the case in every family, but even if you may not have come from a family that supported your ideas and dreams, it is still possible to find the confidence you need to achieve your goals. Furthering your education and supplementing it with travel will go a long way to instilling that confidence so that you are no longer listening as carefully to those voices that hope to discourage you from following your dreams.

The phrase that opened this book and one that I have used intentionally many times is "rise to the occasion." This

means not letting fear and doubt make one feel unable to do something; confidence helps one to do this. In experiencing my story, it is my hope that you, too, will feel secure enough in your own knowledge to be able to not give any energy to fear and doubt. I have learned that these are not things you should waste energy fighting; the better course of action is to not acknowledge their existence or let them govern you.

Rise to the occasion and "take the road less traveled by," because you never know what is around the corner. Turning things down and turning your back on opportunities because you do not feel you can take them on will just mean missed opportunities. You have seen that there have been moments in my own life when opportunities presented themselves that I almost did not seize, but because I believed in myself and allowed myself to rise to the occasion, I was able to take them on successfully.

And yes, luck has certainly been a part of the formula that led to success in my life, but not as much as one would think. Far more than any luck, it has been the ability to say, "How can I not?" rather than retreating behind "How can I?" Doing so has made my road more fulfilling and more fascinating than a small-town girl from Frenchtown, New Jersey, might ever have imagined.

ACKNOWLEDGMENTS

I would not have been able to recount this fascinating journey of mine—spanning as it does, more than eighty years—without the invaluable assistance of many family members, friends, and colleagues. They came to my aid in so many ways, helping to jog my memory regarding the many, and often surprising, twists and turns on this long and wonderful road. I would have been unable to describe my journey as completely and vividly as I have without their help and, thus, my relating of it surely would not have been as interesting.

I am particularly indebted to my sister, Carole Allaire, and to several members of Maan's family: his half-brother and sister-in-law, Dureid and Sawsan Madina; his half-brother and sister-in-law, Hussein and Madiha Madinah, and their son, Tamer; his nephew, Bassem Barazi; his niece, Zein Shubailat; and his great-nephew, Alex Essaid. Last, but certainly not least, in the group of family members who must be mentioned here is my dear, departed mother, who saved

my numerous letters to her over the years as well as newspaper clippings about me.

I would like to express my sincere appreciation as well to my friends: Hillary Cullen, Nancy Druckman, John G. Fritzinger, Richard Keresey, Karen Kern, Noralie H. LaFevre, Katie Marsh, Kevin and Hatice Morrissey, Alice Mosebach, John M. Olivieri, Jennifer Risher, Sharon Sager, Batsheva Schreiber, Jan and Marica Vilcek, and Galen Williams.

I would also like to thank Mary Allen, Melissa Bowling, Rick Epstein, Prof. Matthew Ghazarian, Helen Goldenberg, Maxwell H. Hearn, Prof. Timothy Mitchell, Prof. Nasser Rabbat, Jessica Rechtschaffer, and Aysin Yoltar-Yildirim, as well as the staff of the Aga Khan Documentation Center.

Special thanks must be given to my very old friends Louise W. Mackie and Martha M. Stewart, who kindly agreed to read and provide their valuable insight on the manuscript before its publication and to my dear friend, Sheikha Hussah Sabah al-Salim al-Sabah, for her support in bringing it to fruition.

Finally, I would like to express my indebtedness to and my appreciation of my editor, Francine LaSala; my copyeditor, Mina Samuels; and to my publisher, Arthur Klebanoff, and his team at Rodin Books.

APPENDIX

INTERNATIONAL TRAVELOGUE

1965: JUNE 12–JULY 16
Rome
Florence
Ravenna
Venice
Barcelona
Granada
Seville
Córdoba
Toledo
Madrid
London

1966: MARCH 26–MAY 20
Cairo
Luxor
Karnak
Thebes
Alexandria

Athens
Delphi
Istanbul
Izmir
Ephesus
Berlin

1968: AUGUST
Mexico City
San Miguel de Allende
Acapulco
Oaxaca
Mérida

1969: AUGUST 9–SEPTEMBER 27
Tunis
Qayrawan
Cairo
Amman

Damascus
Homs
Hama
Aleppo
Baghdad
Samarra
Tehran
Isfahan
Nayin
Ardistan
Natanz
Kashan
Qazvin
Sultaniyeh
Paris
London

1971: JANUARY 7–28
Lisbon
Rabat

Fez
Marrakech
Las Palmas,
Canary Islands

**1971: JUNE 13–
JULY 22**
Tunis
Monastir
Mahdiyya
Sus
Qayrawan
Cairo
Tehran
Qazvin
Hamadan
Kermanshah
Bisitun
Taq-i Bustan
Sanandaj
Saqqez
Maragheh
Tabriz
Bandar Pahlavi
Athens
Berlin

**1972: FEBRUARY
2–11**
Tehran

**1972: AUGUST 2–
SEPTEMBER 16**
Algeria
Nicosia, Cyprus
Jerusalem
London
Oxford

**1973: SEPTEMBER
1–OCTOBER 26**
Tunis
Hammamet
Qayrawan
Sus
Sfax
Mahdiyya
Monastir
Sidi Bou Said
Algiers
Plage Moretti
Setif
Constantine
Bougie
Qal'at Beni Hammad
Paris
London

**1974: JUNE 17–
JULY 17**
London
Pisa
Pavia
Faenza
Florence
Rome
Palermo, Sicily
Córdoba
Madrid

1976: APRIL 10–27
Paris
London

**1978: FEBRUARY
8–18**
Tehran
Isfahan
Kirman
London

**1978:
SEPTEMBER 3–
OCTOBER 13**
Valbonne
Athens
Cairo
Kuwait

**1979: JANUARY
28–FEBRUARY 1**
Kuwait

**1979: JUNE 30–
AUGUST 4**
Damascus
Aleppo
Amman
Cairo
Frankfurt
London

**1980: JUNE 15–
AUGUST 15**
London
Cairo
Damascus
Hama
Aleppo
Istanbul
Athens
Cruise: Crete,
Rhodes, Mykonos

1981: APRIL 9–22
Kuwait

**1982: JANUARY
31–FEBRUARY 12**
Kuwait

INTERNATIONAL TRAVELOGUE

1982: MAY 23–JULY 30
Kuwait
Damascus
Cairo
San'a
Paris
London

1982: OCTOBER 3–15
Kuwait

1983: JANUARY 10–MARCH 4
Kuwait

1983: AUGUST 3–10
London
Frankfurt

1983: NOVEMBER 26–DECEMBER 9
Istanbul
Kuwait

1984: FEBRUARY 4–25
Kuwait

1984: AUGUST 5–21
Istanbul
Bodrum
Konya
San'a

1985: MARCH
Kuwait

1985: JUNE 22–25
Geneva

1985: JULY 18–23
Fez
England

1986: FEBRUARY 3–10
Bahrain

1987: NOVEMBER 28–DECEMBER 2
Paris

1988: JULY 31–AUGUST 9
Asilah
Tetouan
Tangiers
Fez
Rabat

1988: OCTOBER 23–29
Amman

1989: SEPTEMBER 13–23
Istanbul

1989–90: DECEMBER 26–JANUARY 6
Marrakech
Casablanca
Rabat
Fez
Asilah
Tangiers

1992–93: DECEMBER 21–APRIL 29
Marrakech
Tinmal
Rabat
Fez
Ouarzazate
Tinerir
Erfoud
Sijilmasa
Tunis
Carthage
Qayrawan
Sus
Mahdiyya
Monastir
Lisbon
Mertola
Seville
Córdoba
Granada
Malaga
London

1997: MARCH 13–24
Mallorca
Seville
Córdoba

1998: MAY 25–31
Paris

1999: APRIL 16–MAY 1
London
Damascus
Jiddah

2000: MARCH 10–APRIL 10
Berlin
Copenhagen
London

2000: MAY 24–30
London

2001: AUGUST 18– SEPTEMBER 18
London
Oxford
Aleppo
Raqqa
Damascus
Konya
Istanbul

2002: MARCH 23–APRIL 16
Kuwait
Damascus
Ma'lula
Aleppo
Raqqa
Istanbul

Bursa
London
Cotswolds

2003: APRIL 14–18
London

2006: APRIL 10–29
Vienna
Prague
Dresden
Strasbourg
Colmar
Basel

2006: JULY 13–19
London

2006: SEPTEMBER 19–OCTOBER 4
Munich
Dinkelsbühl
Rüdesheim-Assmannshausen
Bad Godesberg

London

2013: MARCH 29–APRIL 5
Kuwait
Doha

2014: APRIL 3–6
Mexico City

2016: APRIL 15–27
Kuwait

2019: DECEMBER 15–23
Kuwait
Doha
Abu Dhabi
Dhahran
Manama, Bahrain

2023: FEBRUARY 10–17
Kuwait

BLACK SEA

Istanbul
• Bursa

Izmir
• Ephesus
Bodrum

Konya

MEDITERRANEAN SEA

Aleppo
Hama • Raqq
Cyprus • Homs
Ma'lula
★ Damascus
Jerusalem ★ Amman

Jiddah

RED S

THE LURE OF THE EAST